VOGUE ON

CHRISTIAN DIOR

Charlotte Sinclair

ABRAMS IMAGE
New York

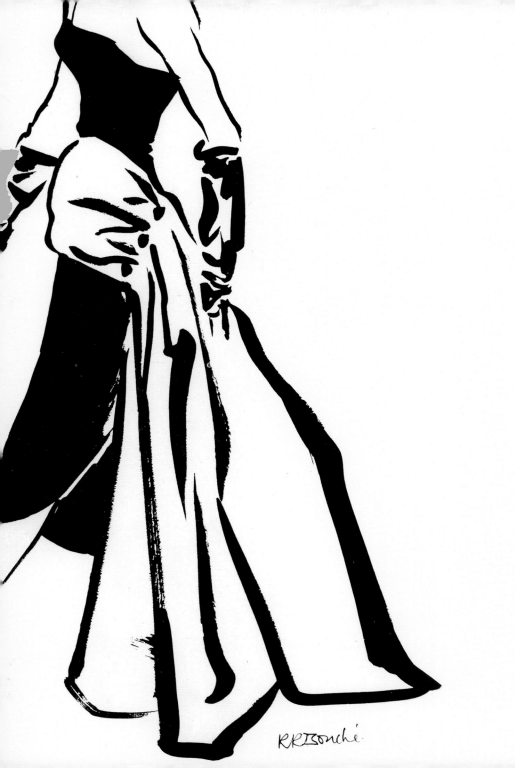

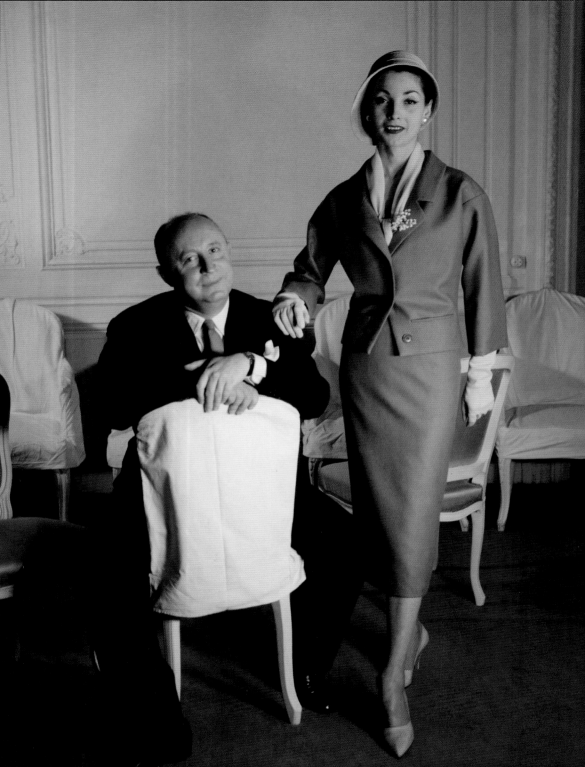

Dior photographed by Henry Clarke for Vogue *with his favorite model, Renée, in 1957.*

page 1 *Dior's monochromatic Mexique dress from 1951. Photograph Henry Clarke.*

pages 2-3 *A René Bouché sketch of Dior's 1949 cocktail dress with sweeping floor sash.*

"OF COURSE FASHION IS A TRANSIENT, EGOTISTICAL INDULGENCE, YET IN AN ERA AS SOMBRE AS OURS, LUXURY MUST BE DEFENDED CENTIMETRE BY CENTIMETRE." CHRISTIAN DIOR

FORTUNE'S FAVOR

Iғ YOU CONJURED AN IMAGE of a fashion designer in your mind, you might not settle on one who looked like Christian Dior. A man "with an air of baby plumpness still about him and an almost desperate shyness augmented by a receding chin" as American *Vogue*'s Bettina Ballard recalled in 1946. Or the "plump, balding bachelor of fifty-two whose pink cheeks might have been sculpted from marzipan," as described by *Time* reporter Stanley Karnow in 1957. The same sugary confection found its way into the great photographer Cecil Beaton's account of Dior: "a bland country curate made out of pink marzipan." Not that Christian Dior was unaware of the shortfall in his appearance. He wrote, "I could not help thinking that I cut a sorry figure – a well-fed gentleman in the Parisian's favourite neutral-coloured suit – compared with the glamour, not to say dandified or effeminate couturier of popular imagination." Dior was a man who knew what a legend should look like.

Photographed for *Vogue* on February 12, 1947—the day his New Look was launched upon the world—Dior is pictured dressed in sepulchral black, markedly glum, giving credence to his description in *Life* magazine as "a French Undertaker." In the photograph the designer looks anything but legendary, anxiety writ large in the downturn of his mouth, in his distracted, sidelong gaze. But in fashion as in life, appearances can be deceptive. In every way that his looks were unmemorable and self-effacing, his fashions were not. Even his couture was a kind of trick, the lightest substance crafted upon the steeliest foundation. Surprise was one of Dior's chief weapons and delights; he was an haute couturier whose clothes made all the fuss and fireworks that he—demure but utterly determined—tried to avoid.

On the eve of his February 1947 debut, Clifford Coffin photographs the new haute couturier, Christian Dior.

Few designers in the history of fashion can be said to have changed the world in any way. But Christian Dior could faithfully make a claim to it. In only ten years at the house that bore his name, Dior revived Paris couture, bestowed a new business model upon fashion, and altered the visual language, so that his vision of how women should dress—Dior's taste and ideals—became the accepted

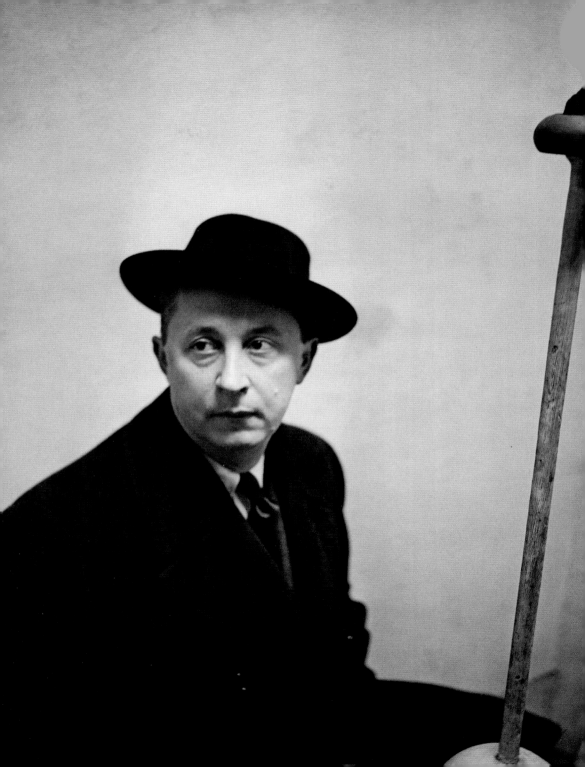

notion of fashion. It was the confidence with which he unleashed his ideas, the determination of his silhouettes, the sheer bravura of his vision—that this and nothing else was the look of the season—that secured his legacy.

So too did his charm, his popularity, his keen embrace of publicity, and his construction of a public character that could be the mouthpiece for Maison Christian Dior. This personality—the well-bred, avuncular couturier who called his fiercely loyal staff *"mes enfants,"* and whose rigorously high standards, in everything from food to *flou*, were built on a solid foundation of kindness and humanity—was arguably just as fundamental to the success of the house of Dior as his winning designs.

Equally, Dior's keen commercial sense—rare in a designer—creating licenses for the Dior name to be carried on everything from perfume to hosiery, ensured that everyone could buy into the Dior dream. Thus he dextrously balanced his work in the high-altitude world of couture with his ready-to-wear operations without debasing either sphere. By the time of his death in 1957, exactly ten years after his debut collection, Ballard wrote, "The magic name of Dior stands for fashion to the masses. It is part of the taxi driver's vocabulary, the teenager's, and it is often the only name that rings a fashion bell in the mind of the average man."

At 30 Avenue Montaigne, the freshly minted house of Dior with its inimitable gray and white awnings.

And *Vogue* was there through it all, from New Look to "H" line, from corsetry to chemise. Front row in the pearl-gray salon of 30 Avenue Montaigne, *Vogue* bore witness to Dior's developments of silhouette, reporting back from the crush and chaos of his twice-yearly collections, feeding an audience anxious to perceive Dior's new direction: the shape of things to come.

"I envisaged my house … would be aimed at a clientele of really elegant women."

CHRISTIAN DIOR

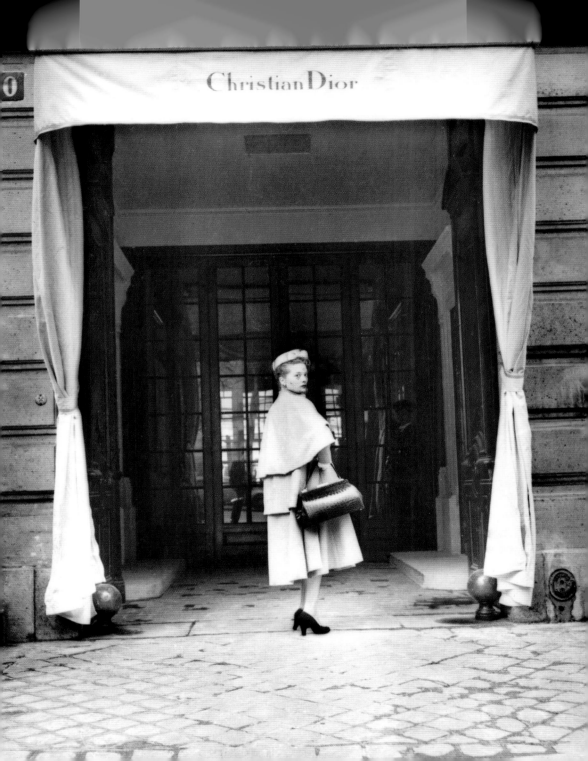

P aris has reigned supreme as the crucible of haute couture since the nineteenth century. A French invention, couture couldn't exist anywhere else than here, in a city where fashion and the art of *comme il faut* have ever been a matter of national pride and civic duty. In Paris designers are lionized, treated as "a sacred monster, a being apart" wrote Cecil Beaton. Yet, as Dior keenly observed, they are kept firmly in check by "a singularly difficult consumer... the Parisienne."

Haute couture is a handcraft industry, a laboratory where beneath one roof, highly skilled *flou* (dressmaking) and *tailleur* (tailoring) ateliers create exquisite, made-to-measure clothing under the direction of their couturier. This rarefied process is enabled by myriad satellite artisans specializing in fine lacework, feathers, trims, beading, embroidery, and ribbon-making; and by fabric houses which source expensive, richly textured, and detailed materials from every corner of the earth. The stratified layers of an haute couture house equal the complex construction of their designs, where from couturier, to *petit mains* (seamstresses), *vendeuses* (saleswomen) to *mannequins* (models), *modeliste* (design assistant) to *premiere* (atelier head), everyone has a specific and vital role to play.

In 1939 there were seventy registered couture houses in Paris. "We flitted from ball to ball under the surrealist presidency of Mme Schiaparelli," wrote Dior of the time. "Fearing the inevitable cataclysm, we were determined to go down in a burst of splendour." Just seven years later, in 1947, everything had changed. Europe was wrecked by war and shattered by holocaust. France and Britain were working to rebuild and revive all that was lost or destroyed during the six years of the war, not least their national economies. Even two years after Germany's surrender, the roads that led out of Paris still bore the buckled and broken track marks of tank warfare. Haute couture was in a vastly diminished state. Severely curtailed during the Occupation, many couturiers like Chanel and Vionnet had simply closed. Others, like Schiaparelli and Mainbocher, had fled to New York. The few houses that were left functioning, including Fath, Balenciaga, and Lelong were subjected to fabric restrictions and were staffed with skeleton workforces. German officers had even attempted to shift haute couture

entirely from Paris to Berlin—a move that would have destroyed the industry—but were persuaded against it by designer Lucien Lelong, then head of couture's governing body, the Chambre Syndicale.

Like all facets of French life, haute couture suffered from wartime privation and austerity. "Paris is still suffering from the effects of the terrible malady of occupation and little improvement in the organisation of life can be seen," wrote Beaton in *Vogue*, 1945. "Prices are much higher, necessities just as scarce, and the black market and other evils more than ever deeply ensconced." A *Vogue* sketch of Paris fashions in 1947 included the telling background detail: "French housewives with precious loaves of bread."

French women tried to remain stylish, constructing—with what little materials they had—extraordinary hats to wear above their boxy jackets and narrow skirts. During the Occupation fashions took their lead from uniform; pants were more practical for the factory assembly line and for riding the bicycles that had replaced cars in gasoline-starved Paris. Dior reviled those "hideous fashions," that to him were equal in aesthetic poverty to the torn out buildings and devastated countryside. "Hats were far too large, skirts far too short, jackets far too long, shoes far too heavy," he complained, "and worst of all, there was that dreadful mop of hair raised high above the forehead in front and rippling down the backs of the French women on their bicycles."

The end of the Second World War did not bring about a return to glamour. *Vogue* observed, "Peace is here, but not yet plenty," and summarily composed a wish list of that which they wanted to "keep, get rid of, have back." Among those to be banished for good: "Austerity – in its limited meaning of cramping dress restrictions, and in its larger meaning of a whole, thin-lipped attitude to life."

"Last year's … Paris hats and skirts were as out-dated as last year's bombs."

VOGUE

And to have back: "Sheer stockings, lots of them… high heels, long evening dresses, silly hats and all the gay nonsense that such a plenitude permits." *Vogue* noted that "austerity is particularly hard worn next to the skin." There was a visceral, vivid need for change. But from where would the change come? Paris offered little to enliven the eye or raise the spirit: "no exciting fabrics, no brilliant accessories, no smart restaurants or parties to whet an appetite for elegance, few smart women to put fashions over, and a crushing luxury tax to kill buying enthusiasm." *Vogue* reported in 1945. "Yet creative changes had to be," the magazine declared, "for last year's … Paris hats and skirts were as out-dated as last year's bombs."

Born in Granville, Normandy on January 21, 1905, Christian Dior grew up in a house overlooking the English Channel, on land hemmed with thick pine forest. His family owned a successful fertilizer factory and the Dior family were wealthy bourgeoisie—a retinue of household staff included a German fraulein to tend to Christian, his older brother Raymond and, his younger siblings Bernard, Jacqueline, and Catherine. The young Christian was solitary; he was happiest "among plants and flowerbeds," or imagining the décor of the Nautilus in Jules Verne's *Twenty Thousand Leagues Under The Sea*. "I could be amused for hours by anything that was sparkling, elaborate, flowery or frivolous," he wrote in his memoirs, recalling the linen room, where "the housemaids and seamstresses, hired for the day, told me fairy stories of devils and sang 'Hirondelle du Faubourg' or the cradle-song from Jocelyn. Dusk drew on, night fell and there I lingered, forgetting my books and my brother, absorbed in watching the women round the oil lamp plying their needles."

Unpublished photographs of Dior in the paneled grandeur of his Paris home, by Cecil Beaton. Also pictured is Suzanne Luling, the directrice of Dior's salon and a treasured childhood friend.

Despite this early affinity for the world of dressmakers, Dior felt no instinct for fashion (unlike the young Balenciaga, apprenticed to a tailor by the age of twelve). In *Je suis Couturier* Dior wrote: "I looked at women, admired the shape of them, was aware of their elegance like all boys my age; but I should have been very much astonished if anyone had prophesied that one day I should be a dress designer."

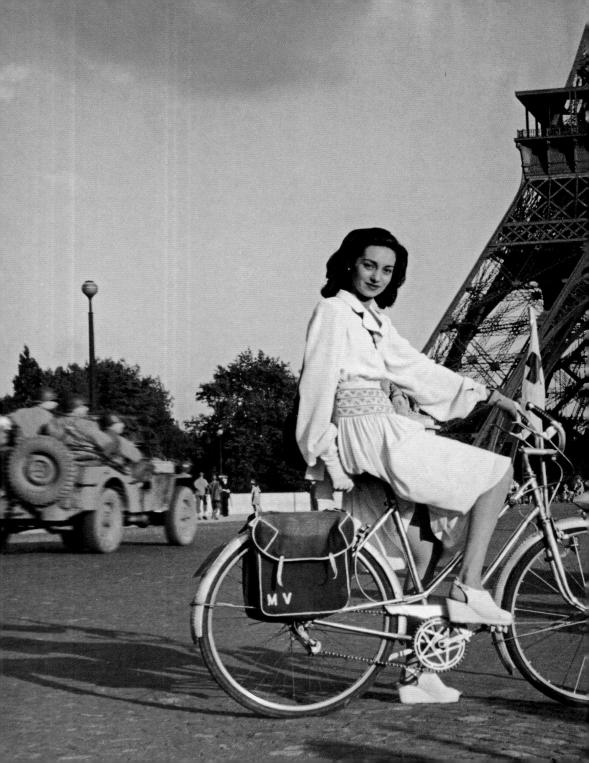

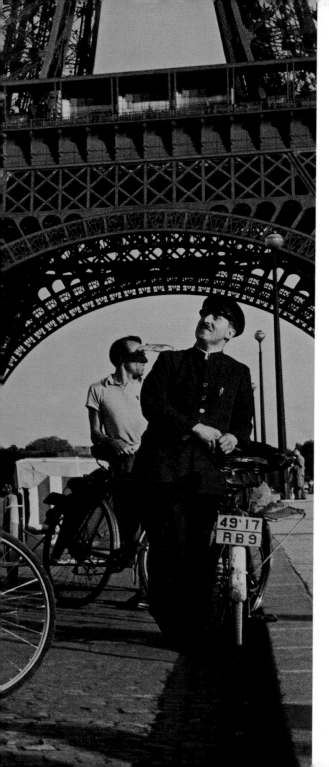

"HATS WERE FAR TOO LARGE, SKIRTS FAR TOO SHORT, JACKETS FAR TOO LONG, SHOES FAR TOO HEAVY."

CHRISTIAN DIOR

"In December 1946, as a result of the war and uniforms, women still looked and dressed like Amazons," wrote Dior. Under the Eiffel Tower, a military truck retreating in the background, a Parisienne poses on a bicycle in a top-heavy blouse and clumpy shoes.

The family moved to Paris in the last years of the Belle Epoque, a style movement that had a compelling, formative influence on Dior. The twitching bustles of the age, its corsetry, peplum-trimmed jackets, duchess satin, lace, bows, and buttons became key tropes in Dior's fashion vocabulary. But by the end of the First World War, a new era was erupting: Modernism. Dior's memories of the 1920s are visual, sensory—the art of the Primitives and Cubists that caught his eye as he wandered Paris, the clean-lined architecture of Le Corbusier; the art of Matisse, Picasso, Braque, the Dadaists, and Jean Cocteau.

New Look garments hid secrets beneath featherlight layers of silk and tulle. Whalebone corsetry gave strictness and structure to even the simplest of pieces, leading one model to declare: "I can't walk, eat, or even sit down."

Directed by his father to the university of Sciences Politique, (who insisted his son train as a diplomat and not in the Fine Arts), Dior ditched his studies to spend his time with a radical, bohemian clique that included artists, writers, and composers such as Cocteau, Salvador Dali, Francis Poulenc, Christian Bérard, and Max Jacob. (He recalled, wryly, "Naturally my family's stable and comfortable position had made me a professed anarchist.") It was an extraordinary period of history. "What a hectic life! German expressionistic films with Conrad Veidt and Louise Brooks, the Ballet Russes replacing Bakst and Benoit with the new Cubist designers, and the Swedish ballets – so 'avant-garde' with their scandalous shows," he wrote. Swept up in a fever for the age, the dilettante Dior opened a gallery dealing in modern art. The enterprise was funded by his father on condition that the family name would never hang above the door. (Considering his later business savvy, it is with some irony that Dior recounted his tussles with his father during this period concerning, "the hideous lust for lucre.")

"Austerity is particularly hard
worn next to the skin."

VOGUE

Luck was a recurring theme in Dior's life story. In his memoirs he declares providence to be the biggest influence on his life, the foundation of all his success. Dior was deeply superstitious. Rare were the decisions made without consultating his clairvoyant, Madame Delahaye. As Stanley Karnow wrote of him, "A devout Catholic, he rarely skipped Sunday mass, but he... regularly consulted an astrologer and swore by her communion with the zodiac."

Thus a mirror smashed in 1930 was perceived by the then twenty-five-year-old Dior, not as an accident, but a portent of bad luck. And so it was: in quick succession, his younger brother and beloved mother died. Months later his father was ruined in the Great Depression. In Paris and broke, Dior had no choice but to dissolve his gallery and sell his Braques and Picassos at a staggering loss. With his apartment seized he found himself homeless, seeking refuge in friends' homes and the "wretched attics" of soon-to-be demolished buildings. Yet an end-of-days spirit in Paris lent vigor to the city's nightlife. As Dior recalled, "nothing stops youth from laughing and having a good time." Nothing except life-threatening illness: Dior contracted tuberculosis and was forced to spend a year in convalescence.

"Dior was born a gentleman," a friend once remarked of him. "It took a catastrophe to make him a couturier." It's fair to say that if Dior had not been bankrupted, his future might have been quite different. Fashion wasn't a viable career option to a man of his background. (Later, his position as something of an equal to his wealthy patrons—in cultural and social standing, in education and peer group—was to set him apart from most of his competitors.) Restored to health and returned to Paris in 1938, an interview for an office position with Lucien Lelong found Dior suddenly declaring an interest in working in the design studio. Dior did not get the job but it gave him focus, a new direction. At the suggestion of a fashion designer friend he began sketching and selling his ideas to magazines and couture houses. His lithe, expressionistic drawings caught the eye of Swiss couturier Robert Piguet and by the outbreak of the Second World War, Dior had been appointed to the studio of an haute couturier.

In war Dior was, he wrote, "rudely torn from my atmosphere of chiffon and paillettes [sequins]," to spend a year mobilised in the South of France, working the land. But by 1942 he was back in Occupied Paris, with a new position as assistant designer alongside Pierre Balmain at the house of Lucien Lelong. "Lelong taught us our profession," Dior recalled, "in spite of all the restrictions of wartime, and the constant fear of a sudden closing."

The last years of the war were grave times for Dior. His sister Catherine served in the French Resistance, gathering intelligence on the German military—courage that was later rewarded with several medals of valor. In June 1944 she was captured by the Gestapo and sent to Ravensbrück concentration camp. Sick with worry, Dior campaigned for her release, and in May 1945 she was delivered, weak and emaciated, by refugee train to Paris. A few years later, her brother was to name his perfume, Miss Dior, in her honor.

Back in Lelong's studio, Pierre Balmain spoke frequently of his intention to open his own house; and in October 1945 he made his triumphant debut. Dior watched his friend's success with interest, but had neither the means nor the courage to realize his own ambitions. By Dior's account, it was only an intervention of luck that set him upon his own course to couture. By chance he met a childhood friend in April 1946 who informed him that the textile baron Marcel Boussac was searching for a new designer to revitalize the house of Philippe et Gaston. Dior listened but dismissed the idea. Providence played her hand and Dior ran into the same friend twice again. At the third meeting—emboldened by his discovery of a lucky omen, a gilt star lying on the ground—he offered himself for consideration.

"All around us was beginning anew:
it was time for a new trend in fashion."

CHRISTIAN DIOR

At the July meeting with Boussac, the shy Dior from Normandy transformed into the other Dior, a couturier of unmatched confidence who had waited long enough to be his own master. In Boussac's office, Dior declared a manifesto—not for Philippe et Gaston, but for his own house. A place "in which every single thing would be new: from the ambience and the staff, down to the furniture and even the address. All around us was beginning anew: it was time for a new trend in fashion" He described in detail the house of his dreams. It would revive "the highest traditions of haute couture" and "great luxury"; it would dress wealthy, discriminating patrons in clothes that hid "elaborate workmanship" beneath "an impression of simplicity."

In an extraordinary gesture of faith, Boussac offered the unknown, untested, 41-year-old designer six million francs to create Maison Christian Dior. Dior accepted—but only after he'd received the vigorous approval of two separate clairvoyants, and cannily ensured his exclusive control over the company and a third of all profits in addition to his salary. News spread fast of this Cinderella story. "By the summer collections of 1946, Christian Dior was a much talked-about personality," wrote Bettina Ballard, "The smell of fame was strong." Outside of fashion circles, he was yet unknown. But it would only be a matter of months before the whole world would learn the name of Christian Dior.

"Magic … was what everyone now wanted from Paris. Never has there been a moment more climactically right for a Napoleon, an Alexander the Great, a Caesar of the couture. Paris fashion was waiting to be seized and shaken and given direction."

BETTINA BALLARD

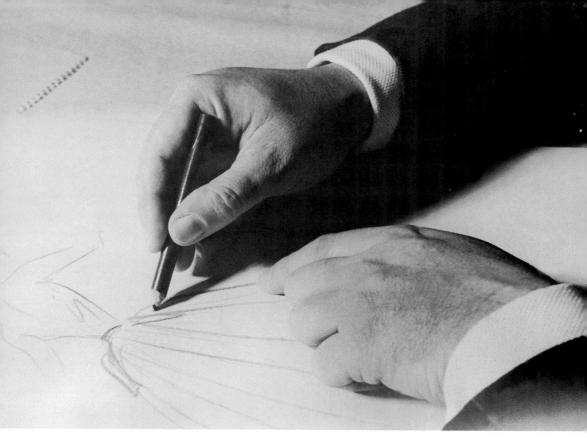

*Dior liked to retreat to his home
in the country to begin sketching
his new collection, often from
the comfort of his bathtub. These
sketches or petites gravures were
then delivered to the ateliers at
Avenue Montaigne, to become
the couturier's new line.*

"THERE ARE MOMENTS WHEN FASHION CHANGES FUNDAMENTALLY. WHEN IT IS MORE THAN A MATTER OF DIFFERENCES IN DETAIL. THE WHOLE FASHION ATTITUDE SEEMS TO CHANGE — THE WHOLE STRUCTURE OF THE BODY. THIS IS ONE OF THOSE MOMENTS."

VOGUE, 1947

NEW LOOK

F EBRUARY 12, 1947 was an unremarkable Paris winter morning. Yet on Avenue Montaigne, an elegant Rive Droite boulevard of tall, Haussman mansions, a fuss was afoot. A well-dressed but vociferous crowd had gathered at number 30, sheltering beneath the gray canopies of the new Maison Christian Dior. The noise from this assembly rose steadily; as women in furs waved invitations, and jointly fumed each time one of their number—couture grandee Lady Diana Cooper or *Harper's Bazaar* editor Carmel Snow—was ushered through the doors. Opportunists attempting to penetrate the building via a ladder to the ateliers above were quickly ejected by security guards.

Inside, pale gray paneled walls, small gold chairs, and glittering chandeliers lent a nineteenth-century grandeur to the scene. The scent of paint mixed with perfume in the air, and in her front row seat American *Vogue*'s Bettina Ballard was conscious "of an electric tension that I had never before felt in the couture." Even the salon's staircases were co-opted to seat the expectant crowd, crushed four or more to a step. There was a moment of hush, and then at 10.30 exactly, "The first girl came out, stepping fast, switching with a provocative swinging movement, whirling in the close-packed room, knocking over ash trays with the strong flare of her pleated skirts, and bringing everyone to the edges of their seats in a desire not to miss a thread."

Marlene Dietrich triumphantly holds up her invitation for a Dior show in 1955. Buyers and press were often willing to forgo comfort and, at times, dignity, to cram themselves onto the salon's staircase to view the show.

F or women starved of luxury, Dior's "Corolle," or "flower" line, was manna from heaven. Models wore full skirts that dropped to just over 14 inches from the ground. Waists were corseted and hips were padded. Busts were prominent and rounded, contrasting with an unstructured, softly sloping shoulder line—a direct rebuff to the boxy shapes which had proliferated in postwar Paris. "Arrogantly swinging their vast skirts," the models made their loop of the packed salon, "contemptuously bowling over the ashtray stands like ninepins," wrote Ernestine Carter of *The Sunday Times*. The look was utterly

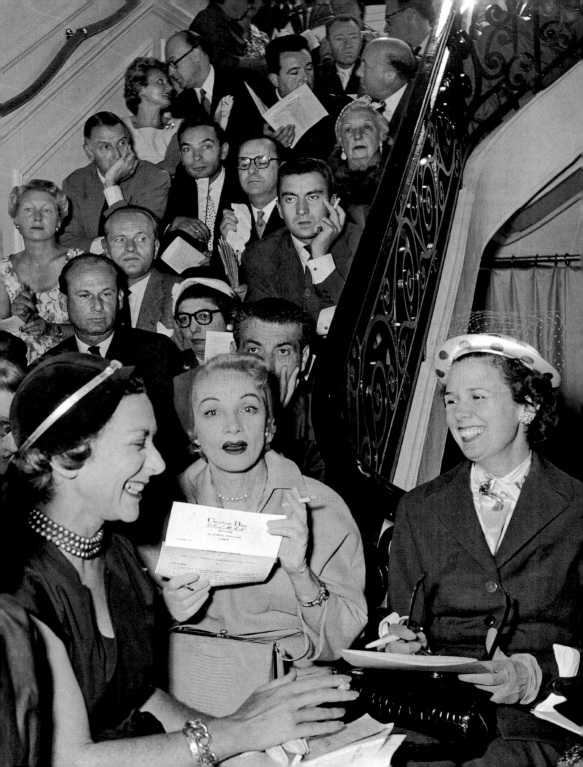

feminine, drawing on Dior's memories of the tight corsets and low décolletage of Belle Epoque silhouettes, and—with up to 45 yards of silk used in just one dress—outrageously decadent.

Fashion's dominant aesthetic was swept away: this was fashion as architecture. Dresses lent the *modeles* their shape not vice versa, imposing a tiny waist and full bosom through ingenious internal engineering. (The complicated construction of even the simplest item of Dior's couture seemed to necessitate the employment of a maid—an explicit sign of Dior's target market and the demand for a certain standard of living inherent in his designs.) The lightest puff of tulle was lent sculpted rigor by armature. Carmel Snow recalled a model saying, "It is the most amazing dress I have ever seen. I can't walk, eat, or even sit down." Dior wanted his clothes to be constructions: "Thus I moulded my dresses to the curves of the female body, so that they called attention to its shape."

Greeted with vigorous applause, the Bar Suit was evidence of this strategy, featuring a neat shantung silk jacket with peplum worn with a heavy wool skirt which floated over padded hips and wasp-waisted guêpière corset. *Vogue* reported, "He pads these pleated skirts with stiff cambric… he builds corsets and busts into the dresses so that they practically stand alone." But rather than rendering a stiff, austere aesthetic, the New Look was all softness and unashamed femininity. These were clothes to seduce in.

Taking inspiration from the unfurling petals of a flower, "Corolle" featured cascades of material. Austerity measures were defied in one swoop of Dior's effusively layered skirts. The sheer volume of silk and wool and satin that he presented was an act of celebration as much as an elitist statement: the flaring, swishing antithesis of the coal shortages and bread queues rife across Europe. "Temperamentally I am reactionary," wrote Dior, "we were just emerging from a poverty-stricken, parsimonious era, obsessed with ration books and clothes coupons: it was only natural that my creations should take the form of a reaction against this."

Dior's modeles displayed in his magnificent chandeliered salon to an audience well supplied with the designer's extensive program notes.

overleaf *In sketch—by Christian Bérard—and photograph, the star of Dior's debut "Corolle" line, the Bar Suit. Featuring a shantung silk jacket with a softly sloping shoulder line and a full skirt worn over padded hips, the Bar suit was sober but extraordinarily lavish.*

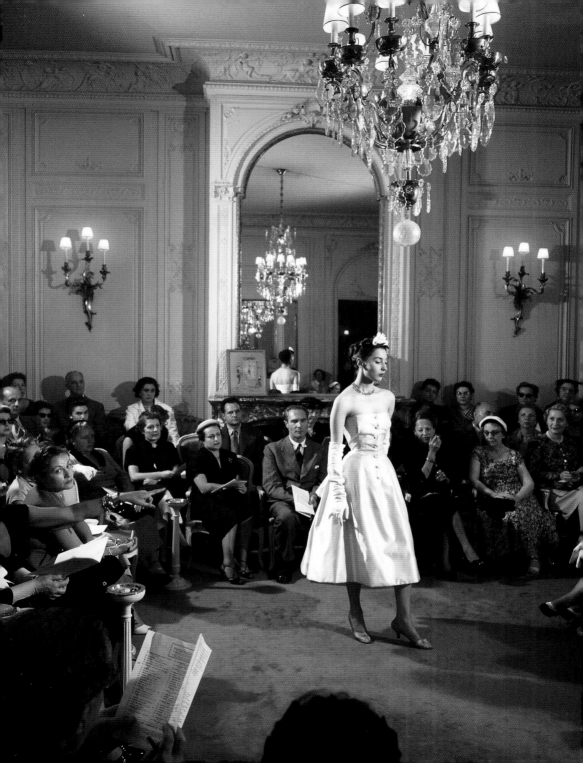

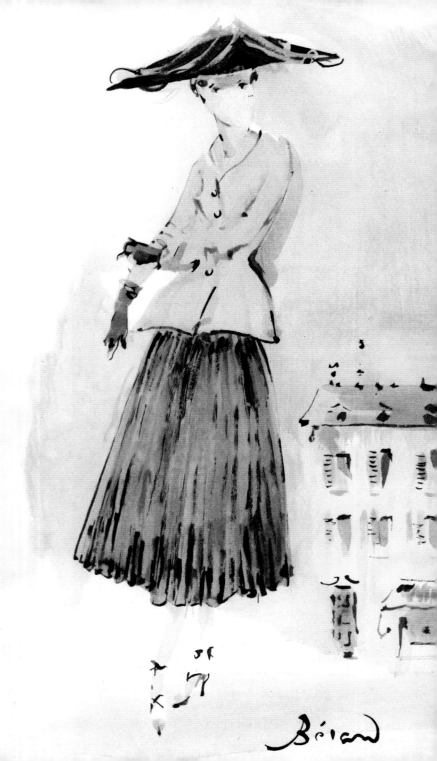

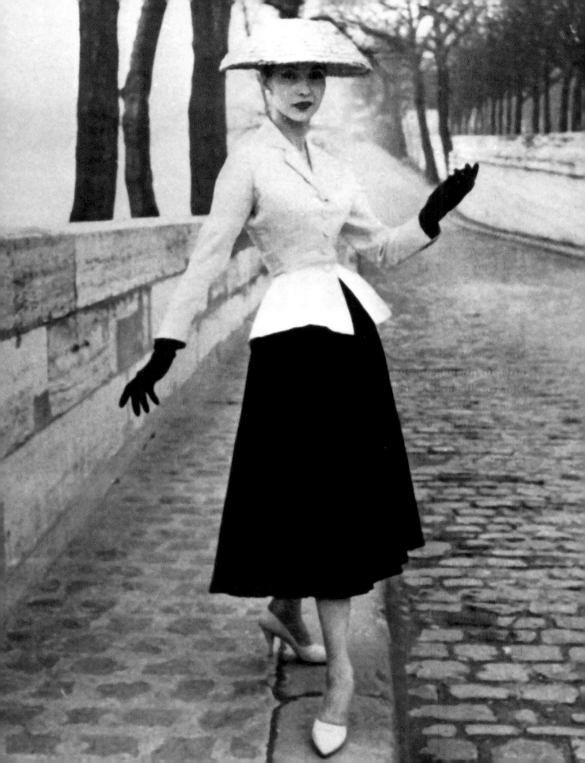

As Dior entered the main salon at the close of his two-hour presentation, the audience rose to a standing ovation. Besieged by "a shrieking throng of reporters, editors and buyers," *Life* reported, "he had been heard to murmur, 'My God, what have I done?'." Days later, Carmel Snow wrote to the designer, "It's quite a revolution, dear Christian. Your dresses have such a new look."

It had been a collection produced, "under conditions of unbelievable difficulty" Dior recalled. "Worn out by the triple task of organising the business, recruiting the staff, and creating the dresses, I sometimes let myself flop down exhausted on to the heaps of material." Though a key *premiere* collapsed with a nervous breakdown, ("a victim of this mad regime"), his new staff held as firmly as the whale-bone waspies they sewed into his dresses. Aiding Dior in the creation of the New Look were three women of such crucial importance to the couturier, that Beaton dubbed the quartet, "Dior and the three fates." Raymonde Zehnacker was the designer's deputy, a woman whom Dior described as "my second self," and credited with providing, "Reason to my fantasy, order to my imagination, discipline to my freedom." As well as helping Dior run his house, she was a treasured intimate (though not a lover— Dior was homosexual), and was with Dior in Italy the night he died.

The feline beauty Mitzah Bricard played muse to Dior (some histories have the enigmatic Bricard as a reformed courtesan, others as merely the possessor of a number of rich lovers—the source, perhaps, of her extraordinary collection of jewelry). Lastly, there was Dior's "Dame Fashion": Marguerite Carré, *directrice technique* in charge of the execution of the couturier's sketches, and for whom, as Dior wrote, "Nothing is ever beautiful enough, or perfect enough."

Premieres and *secondes* were appointed to oversee the *flou* and *tailleur* ateliers, in which white-coated *petite-mains* busied with needles and thread. Dior's childhood friend Suzanne Luling was made *directrice* of the salon, marshaling clients with all the diplomacy and charm that such a role required. Jacques Rouet monitored Maison Dior's finance and business endeavors, and a young American, Harrison Elliott, was employed to deal with "the goddess of our age – Publicity."

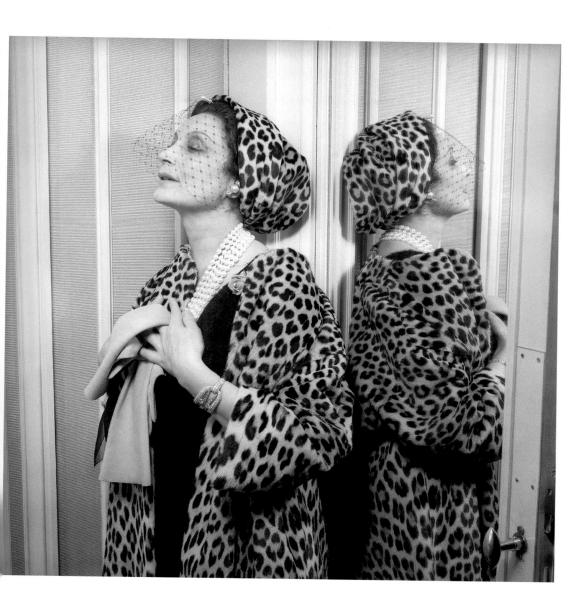

*Mitzah Bricard dressed in her favorite
leopard print. Supremely chic, she
"understood only extravagant elegance
– exactly the right attitude for the haute
couture," observed Bettina Ballard.*

"IT TOOK
ONE SWISH
OF THE
HIPS AND
AMERICA
WAS WON."

COLETTE

A search for a *cabine* (a stable of house models) turned to farce when a cohort of "ladies of the street" arrived at the couture house; Dior, with typical good manners, interviewed them all. He eventually cast a cadre of predominantly brunette models whom he treated like treasured—if somewhat spoilt—children. Interior designer Victor Grandpierre was charged with creating the sober gray and white decor which gave the house its distinct visual signature, and which was later to be replicated in Dior's outposts around the world. A boutique covered with *toile de Jouy* fabric, "intended to be a copy of the eighteenth-century shops which sold luxurious trifles" was added on the ground floor.

Dior's design process always followed a pattern. Two months before he would begin to sketch a new collection, a cortege of lace-makers, embroiderers, and fabric merchants bearing textiles from Scotland, China, Lyons, Zurich, or Milan arrived at 30 Avenue Montaigne, spilling "multi-coloured pieces with the quickness of a conjurer" at the feet of the couturier. After making his choices, Dior retreated to the country to begin working on ideas, sketching thousands of silhouettes, often from the comfort of his bathtub. "Ideas flock into my head one after the other; a single sketch starts off a whole series," he wrote.

Back in Paris, these *petites gravures* were delivered to Madame Carré. "Like sap, the creative idea circulates now throughout the whole building. It reaches the apprentices and the seamstresses, and inspires the fingers which are working on the *toiles* [the first incarnation of the design, usually made in muslin]." From the endlessly refined *toiles*—and after the laborious process of matching fabric to design —Dior selected the principal looks to be put into production. At the rehearsal, the couturier—in a white coat and brandishing a baton to point out deficiencies—could dismiss a dress that had taken 100 hours to produce. (The makers of these spurned items often beseeched *le patron* for a reprieve—usually with success.) "Balances are rectified, proportions adjusted. Finally, bristling with pins, studded with pieces of cotton *toile*, fluttering with pieces of material... the dress leaves the studio... almost unrecognisable."

At the dress rehearsal the completed looks, or *modeles*, were matched to a Cinderella's trousseau of jewels, umbrellas, handbags, gloves, shoes, furs, buttons, and bows, and christened with names like "Gitane" or "1947," which would be declared at their entrance. From first *toile* to final presentation, Dior followed the progress of each dress "like an anxious father – proud, jealous, passionate, and tender – suffering agonies on their behalf. They have absolute power over me, and I live in perpetual dread that they will fail me." They did not. The New Look, he wrote, "was successful beyond my wildest dreams."

Immediately after the presentation, Ballard recalled, "some of us stayed and tried on the extraordinary new clothes, slightly drunk with the excitement of it all, whirling around in the knife-pleated skirts." The American buyers, having foregone the presentation and gone back to New York, were informed of the commotion at Dior and forced to return. Wires were sent to news agencies around the world, warning women that their existing closets had, in a matter of two hours, become defunct. As the writer Nancy Mitford wrote to her sister, "My life has been made a desert of gloom by the collections which at one stroke render all one's clothes unwearable!"

Crowds flooded the daily presentations at Maison Dior. Well-bred women battled over appointments with their favorite *rendeuses*. "Even at these prices (evening dresses £340, nothing at all under £100)," Mitford wrote, "it was exactly like a bargain basement and you had to fight to be allowed to order!" (In today's money it means evening dresses were approximately £10,000, and nothing was less than £2,500.) Susan Mary Patten, the wife of a US diplomat, recalled, "The richest ladies in Europe were screaming for the models, shrill cries of 'Where is Miss New York? I had it and someone has stolen it right from under my eyes.'" Such was the speed at which the news of this fashion revolution traveled that when the actor and actress Laurence Olivier and Vivien Leigh attended a presentation Leigh noted, "Everyone there had a Chicago accent."

overleaf Dior at work in his studio, dressed in his regulation white coat and carrying the baton he used to point out errors and adjustments as the collection took shape. Here, the couturier assesses the charts which organized his collection. These featured a sketch of the outfit, its name and number, its fabric, and a brief note on matching accessories.

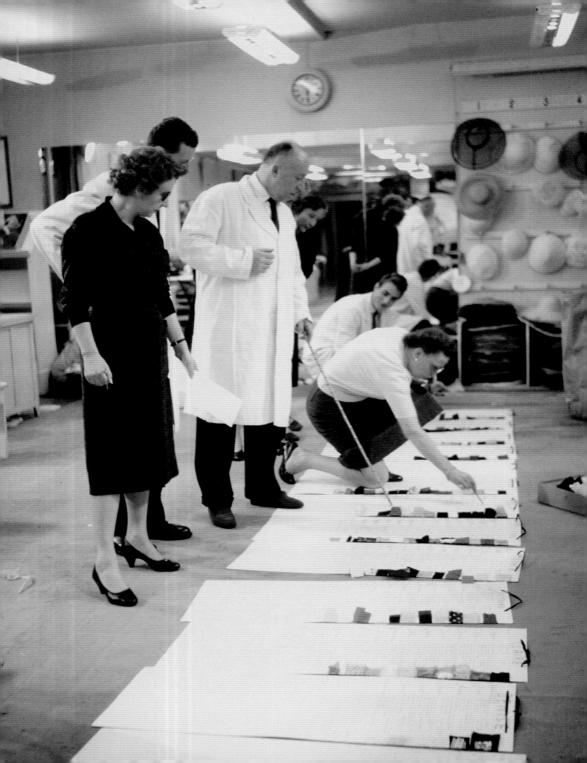

N. 14 Atlantic

Colette

ceinture avec frange

24 JAN 1949

DIOR
...e – PARIS-8e

Dior's fame spread fast. Buyers and press packed the salon. *Life* magazine photographed the new couturier for a cover story; and Dior was invited to Dallas to collect an award for his services to fashion. "Christian Dior the public figure, now came into his own," he wrote. He could not move through the city without being recognized. In Paris, with the house now producing thousands of repetitions of the New Look's winning *modeles* for buyers and private clients, Maison Dior opened two more ateliers and tore down the building's stables to make room for more.

Within months, the house had grown to ninety employees, attained a turnover of 1.3 million francs, and accounted for seventy-five percent of all French haute couture exports. Buyers from American department stores Henri Bendel and Neiman Marcus bought Dior's *modeles*, copied them in American fabrics, and sold them to a feverish market. In only a matter of weeks, the New Look's full-skirt cinched-waist silhouette had percolated through the entire American fashion market, a situation repeated across Europe, South America, Japan, Australia —anywhere in the world where women wanted to look fashionable. In New York, recalled Ballard, "Even taxi drivers asked me, 'Is this the "new look"?' So quickly did the expression become part of our everyday vocabulary." Suddenly, New Look was *the* look.

From Vogue, *November 1947, a sketch by Eric. A woman in the streets of Paris wears Dior's ingenious, trompe l'oeil coat dress—the green collar and pleated front panels are part of the coat itself.*

Its success was propelled, too, by a frisson of scandal. French newspaper *L'Humanité* blustered angrily, "Again the capitalists are squandering resources while poor children go hungry." *Combat* called for a revolt: "*Aux ciseaux, les citoyennes!*" ("Citizens! To your scissors!") Women protested, shouting, "40,000 Francs for a dress and our children have no milk." A photographer captured a model being attacked on a Paris street, her Dior dress ripped to shreds by a posse of enraged matrons. In Britain, *Vogue* was urged by the Board of Trade not to report on Dior's collections in case readers were tempted to defy austerity regulations. The Labour Government even considered introducing legislation to monitor skirt lengths. In America, Dior was greeted on tour by placards that read, "Mr Dior, we abhor, skirts to the floor."

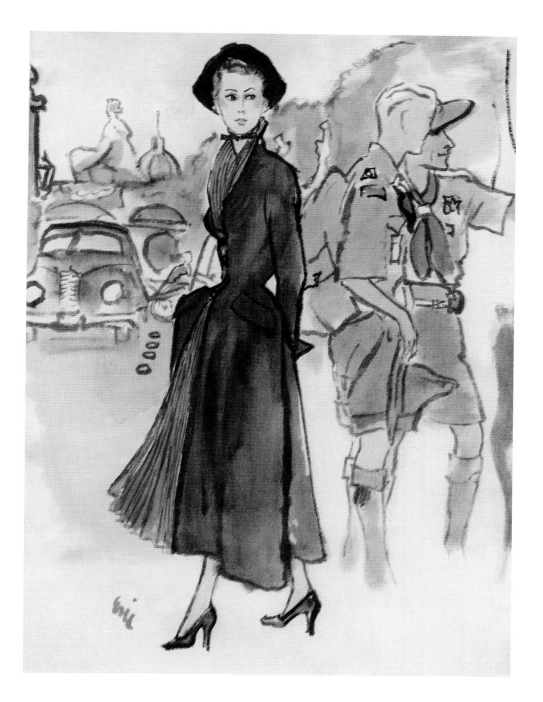

*Dior's ateliers housed a cadre of petit-mains,
dressmakers of extraordinary skill, pictured
here hard at work. Lined up on a shelf above
are made-to-measure mannequins, one for
each of Dior's private clients.*

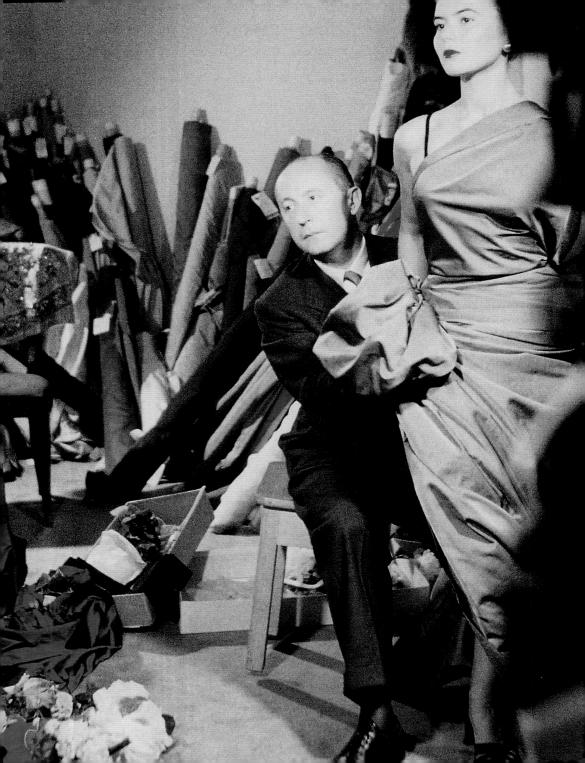

"WOMEN HAVE INSTINCTIVELY UNDERSTOOD THAT I DREAM OF MAKING THEM NOT ONLY MORE BEAUTIFUL, BUT ALSO HAPPIER."

CHRISTIAN DIOR

In Dallas, the "Little Below the Knee Club" was founded to preserve the sanctity of the American leg; in the era of Bettie Grable and pinup girls, they viewed Dior's drop skirts as downright unpatriotic. (*Time* reported of its activities: "Short-skirted girls chased long-skirted girls with brooms. They cried, 'Down with the long! Up with the short!'") They fought a losing battle. Many women, as Cecil Beaton observed, "persisted in their old ways and refused to adopt the new extremes in skirt length over padded crinolines. But... within several seasons any woman in an 'old look' dress was marked for pity and ridicule."

Photographed for Vogue by Serge Balkin in 1947, a pleated summer dress is extravagant with material, but displays delicacy and refinement.

previous page Dior, pictured draping fabric around his house model, Sylvie. Several months before Dior began sketching, the house would be visited by fabric merchants from all over the world.

When Hollywood started wearing Dior—Ingrid Bergman, Ava Gardner and, later, Marlene Dietrich in Hitchcock's *Stage Fright*, Lauren Bacall in *How to Marry a Millionaire*—the game was up. Even the Royal Princesses, Elizabeth and Margaret, were given a private presentation of New Look in London, (though they were forbidden to adopt it by their father King George VI—Princess Margaret had to wait until her twenty-first birthday party to wear her first Dior couture). "If there could be a composite, mythical woman dressed by a mythical, composite couturier, she would probably wear her skirt about fourteen inches from the floor," wrote American *Vogue* of the New Look's unparalleled popularity.

But some viewed the ultrafeminine ideal emanating from the salon of Maison Dior in graver terms than its profligate use of material. In wartime, women had been praised by Winston Churchill for undertaking "all kinds of tasks and work for which any other generation but our own... would have considered them unfitted." Postwar, *Vogue* warned: "It is up to all women to see to it that there is no regression." Dior's corseted, restrictive silhouette seemed to oppose all these precious new freedoms and equalities, reducing women to object and ornament.

The New Look was about looking, being gazed at—specifically by men. These clothes exaggerated women's femininity, the critics cried. The designs trapped women in the aspic of old-fashioned values.

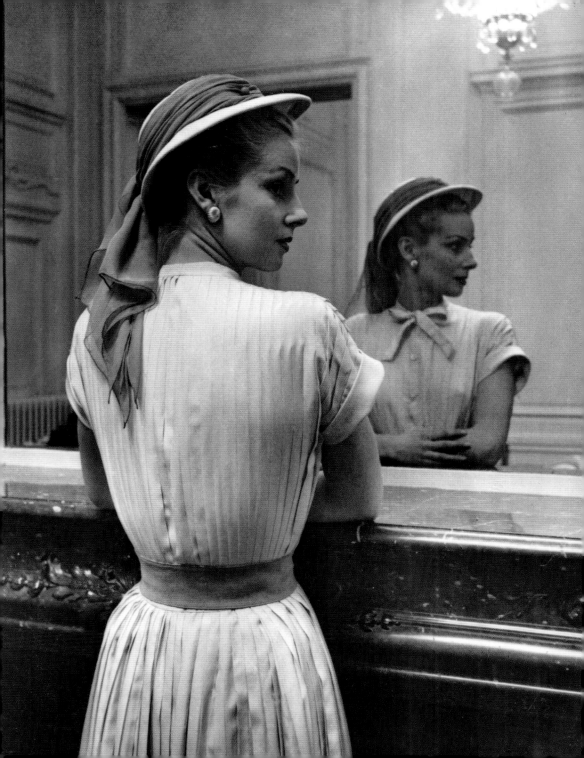

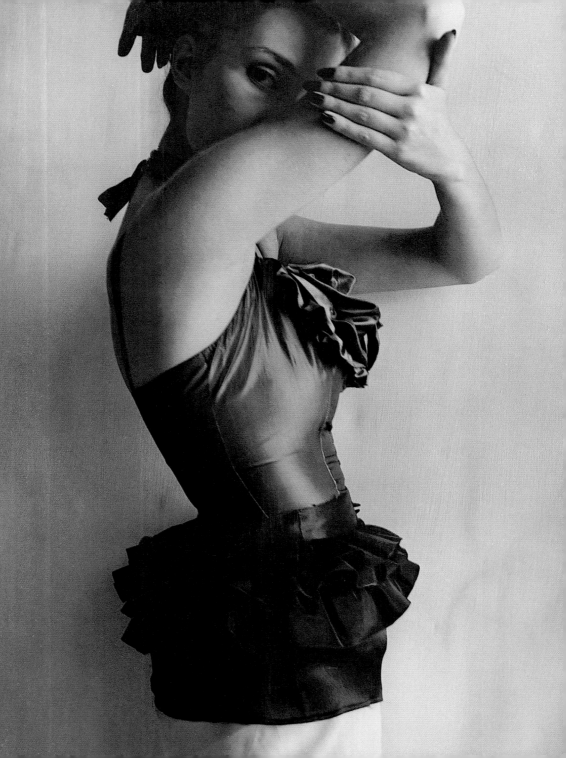

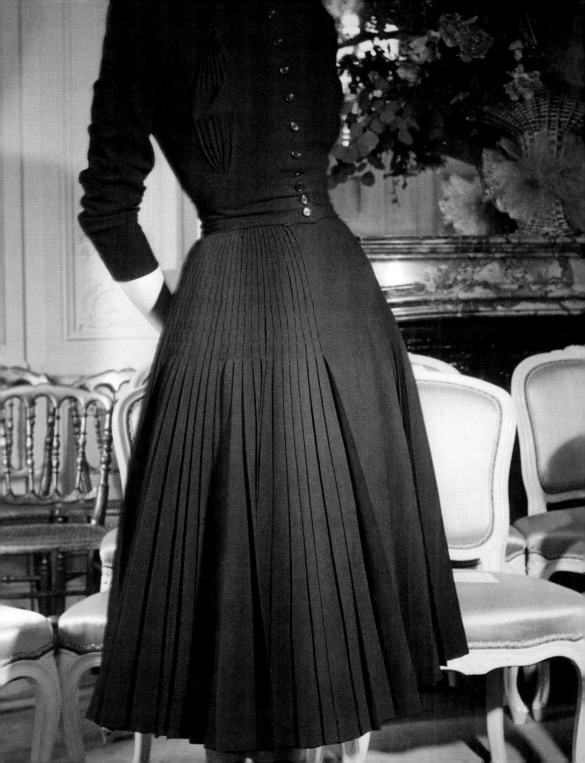

It was, as writer Simone de Beauvoir described in 1949's *The Second Sex*, "elegance as bondage." (A view shared by Coco Chanel, who proclaimed, "Dior? He doesn't dress women, he drapes them!")

Yet, for the majority, the New Look was an expression of optimism, it meant a welcome return to gender balance after the upheaval of war. And what was couture if not, as *The Atlantic* magazine put it, "the most finely wrought expression of femininity ever devised?" As Dior wrote, "Women have instinctively understood that I dream of making them not only more beautiful, but also happier."

Dior proposed New Look not only as a fresh mode of dressing, but as a reassertion of the human and artistic in the age of the machine and the atom bomb. "Our contemporary problems have brought us face to face with an uncultured and hostile world," Dior told Cecil Beaton. 'That is why the mode in women's dress has become increasingly feminine... Our civilisation is a luxury, and it is that we are defending." For France, a country that had suffered the ignominy of Occupation and the Vichy Government, that in 1947 was at war in Algeria and Indochina, Dior's worldwide success was a much-needed reaffirmation of national values. Within the Paris fashion industry, Christian Dior was cast as the savior of haute couture.

Thus, the New Look, "with its direct, unblushing plan to make women extravagantly, romantically, eyelash-battingly female," reported American *Vogue*, launched the postwar world for women. "That's what we talked about then – the post-war world, which seemed to arrive by fits and starts. And while new cars and nylons and automatic washing machines filled it with patches of green pastures, the real Elysian lift – the smirky, cat-in-cream thing that happens to women in front of mirrors – came out of Dior and Paris. At the precise grey moment in time when the fashion business was hinting at the decline of French couture, suddenly one of its own, namely Dior, stirred up a most reviving fuss."

A model in Dior's romantic New Look stares into the future in this photograph by Horst.

previous pages *Clifford Coffin photographs Dior's corsets to reveal the secret of his silhouette, ruffled padding at the bust and a flaring peplum at the hip (left). A black day dress from Dior's debut collection, photographed by Serge Balkin for* Vogue *in April 1947. Small details—the vented pleating at the bust, tiny buttons, a handspan waist—emphasize Dior's vision of femininity (right).*

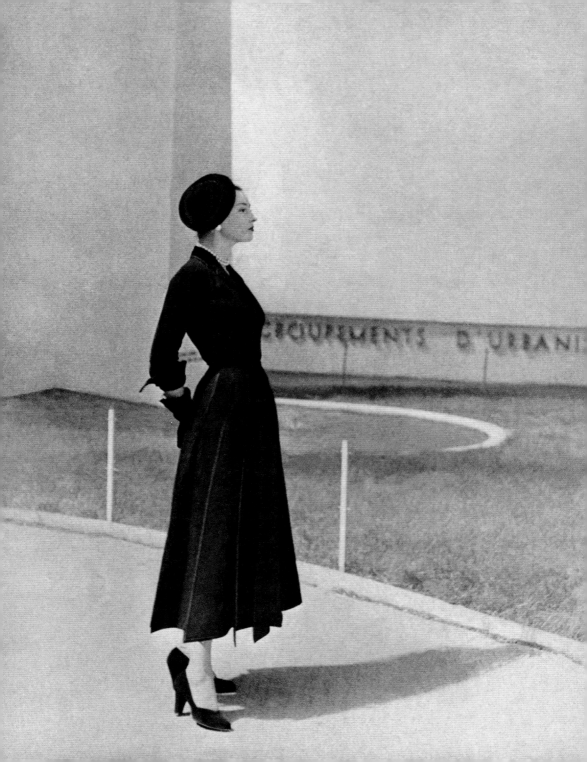

CHANGING SEASONS

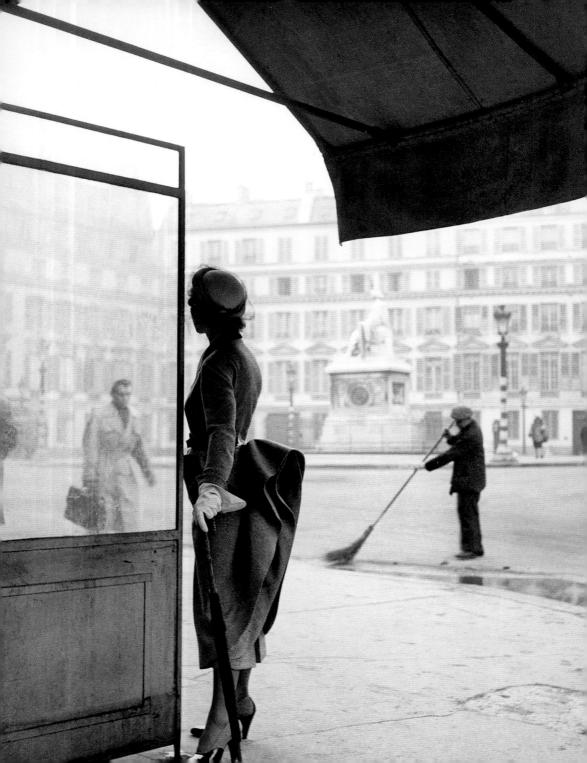

WITHIN MONTHS OF HIS DEBUT, Dior's Avenue Montaigne house had become the beating heart of the fashion industry. Each season was anticipated with feverish excitement. Not least for the fact that each new collection guaranteed a diversion from the last, an alteration of the silhouette, something fresh to snag the eye. Dior's constantly evolving imprint—part strategy, part innovation—was unique. Until Dior, a couturier would work an idea out gradually, her designs a continuation of a conversation that might have begun several years previously with a particular line of dress, shoulder, or sleeve. To have a volte-face each season was extraordinary; and controversial. Critics accused Dior of creating change for the sake of it, of concocting a fixation on hemlines that had little to do with fashion and much to do with fame seeking.

Of course this was true only to a degree. Dior was certainly attuned to the needs of the press, including in each collection what he called "Trafalgars," the dramatic looks "which make the covers or big pages of the magazines. It is these models which determine the fashion of today, and also that of tomorrow." But these were rarely put into production. In fact, Dior's sharp commercial nous meant his collections included a swathe of *modeles* that continued, from season to season, the lines which were popular with his core clientele.

Yet Dior's practice of naming each collection with a word— "Flight," "Tulip," "Free"—to pinpoint its particular atmosphere made it seem as if the couturier was remaking the world each season. (Appearances *were* reality for Dior, a notion evident in every stitch of his couture.) He wrote: "I arrive at the name which concretizes the tendency of the day by thinking in terms of the most marked silhouette of the collection," adding that this involved "sacrificing the truth and my hatred of extremes to the modern taste for a slogan." It was a sacrifice that nonetheless he made gladly, since it guaranteed Dior remained front and center of the fashion industry for his entire career.

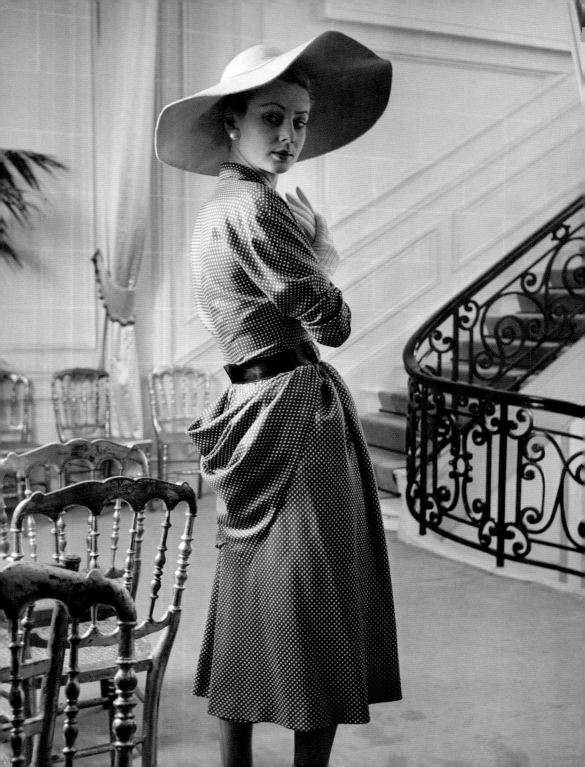

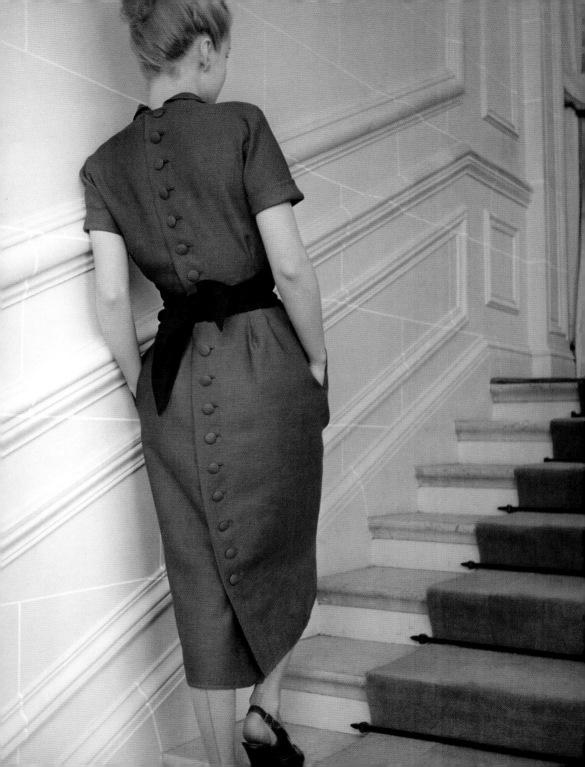

"I MOULDED MY DRESSES TO THE CURVES OF THE FEMALE BODY, SO THAT THEY CALLED ATTENTION TO ITS SHAPE."

CHRISTIAN DIOR

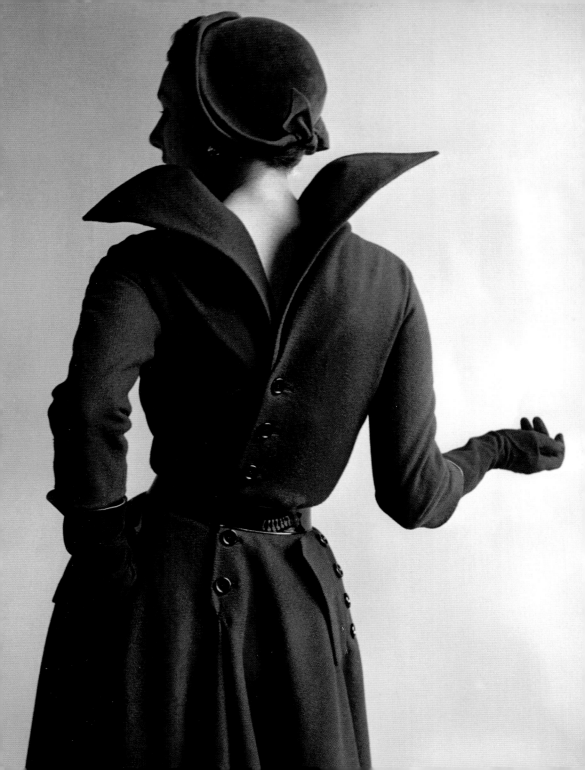

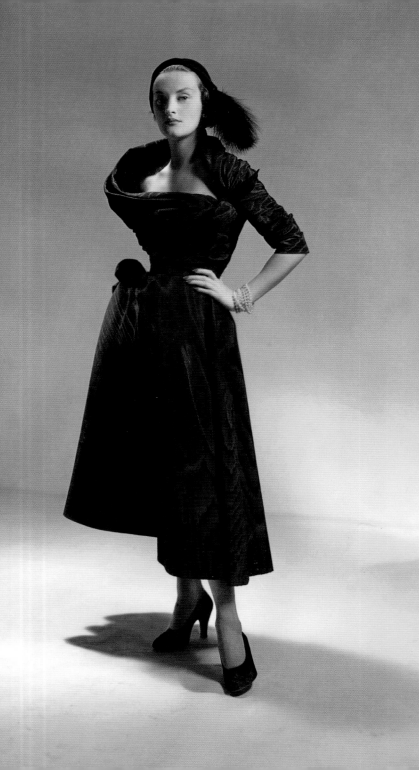

With collections called "Envol" and "Zig Zag," Dior's 1948 couture experimented with ideas of flight and movement. Clothes were given energy and lightness by means of asymmetrical, swooping hemlines, thrusting bustles, and torque collars that reached up and away from the neckline. The basic New Look shape—the tiny waist, soft shoulder, long length—remained but, as *Vogue* wrote, "skirts focusing entirely on back interest" were the order of the day. This *derrière de Paris* featured gathered or stiffened fabric that appeared to bloom straight from the small of the back, beneath which skirts were full, and built on padded foundation, or slim and straight. Peplums gave a less exaggerated nod to the trend, as did a dress with buttons marching up the back.

With a silk moiré dress from October 1948's "Zig Zag" line, an asymmetric, draped collar balances an opposite hip detail. Photograph by Arik Nepo.

previous page "Zig Zag" found inspiration in movement. Here, the collar on a reversed, back-buttoned dress lifts high above the shoulders, echoing the wings of a bird in flight. Photograph by Clifford Coffin.

1949's "Trompe L'Oeil" and "Mid-Century" collections continued with Dior's interest in line, as well as surface detail, reinforcing his basic ideas. Pockets abounded, adding volume to a tight, slim skirt or molded bodice, making an outsized design gesture on a pleated skirt. Tube skirts were, *Vogue* reported, "so narrow they must be slit for walking." After Mid-Century's debut, over 1,200 dresses were ordered in just eight days.

The "Oblique" and "Vertical" lines for the new decade, 1950, developed Dior's obsession with form. As he wrote in the program for "Vertical": "This line, clear and stripped of inessentials, confirms the tendency hinted at for two seasons, and remains essentially feminine, for it is intended to make women value Woman." Horseshoe necklines showed off deep décolletage, skirts were narrow, falling to mid-calf, and off-angle fastenings showed a geometric thinking. It was an inversion of the New Look shape with "big sleeves from a dropped shoulder, a loosened bodice, flattening the bosom" and narrow skirts, recalling the straight silhouette of the Twenties, *Vogue* reported. "Fashion in Paris, depends on the figure" the magazine warned. "And the figure had better be good!"

Dior's geometric interest continued with 1951's "Oval" and "Long" collections (the latter was also known as the "Princess" line). "Oval" was, as *Vogue* noted, "oval neck, oval sleeves, oval hips."

Winter 1949's "Mid-Century"
collection played with contrast.
Here, René Bouché's sketch for
Vogue depicts a jacket with
billowing sleeves counterbalanced
by a strict pencil skirt.

overleaf Evoking the Surrealist
work of her friend Man Ray, Lee
Miller photographs a dress from
1950's "Oblique" line for Vogue.
The model appears to float in the
air unaided, while her ball gown
falls to the ground.

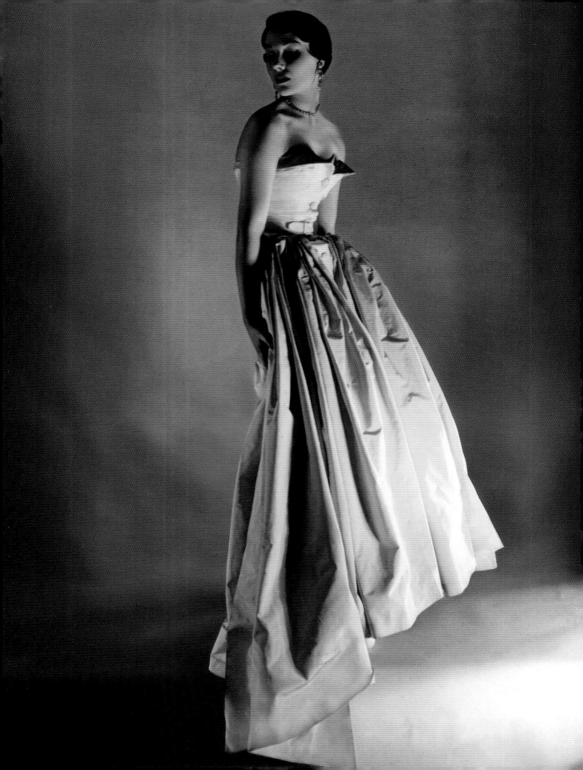

"THE MODE IN WOMEN'S DRESS HAS BECOME INCREASINGLY FEMININE ... OUR CIVILISATION IS A LUXURY, AND IT IS THAT WE ARE DEFENDING."

CHRISTIAN DIOR

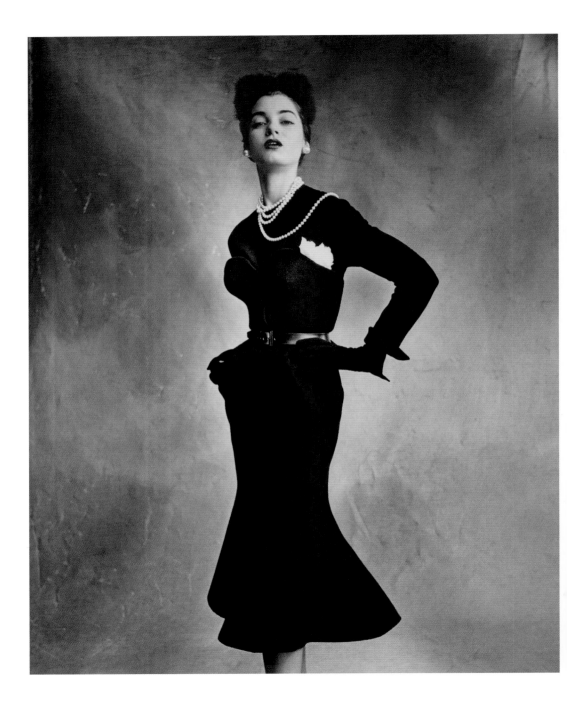

Dior dispensed with the padded, pleated look of the New Look and made "carved oval dresses with skirts you could walk in." His monochrome spencer suit—a neat, ovoid, cream shantung jacket worn over a black sheath dress that nipped in at the waist and curved over the hips—was as evocative of Dior's new direction as the New Look's Bar Suit. The sculptural "Princess" look featured an uninhibited line running from shoulder to hem. With "an inch and a half added to the length, a high-waisted effect at the bodice, no belt to break the line, Dior arrives at giving the maximum length to the body," *Vogue* reported. Hips were rounded, skirts were straight but soft, the waist was resolutely elevated. To accentuate this effect, Dior showed "a whole series of devices to carry the eye high: tiny spencers that knot between the breasts; boleros chopped off at the ribs; martingales [cropped shrugs] practically under the shoulder blades."

The "Vertical" line, as depicted by Irving Penn, September 1950. A unified line, from top to bottom, fits at a molded bodice and flares at the hem to pick out the feminine silhouette.

overleaf Dior's spencer suit, photographed by Henry Rawlings, exemplified the "Oval" line (left). A collection of pleated suits in pastel colors and shorter skirt lengths found Dior relaxing his New Look silhouette for 1952's "Sinuous" line (right). Photograph by Horst.

Dior developed these more wearable ideas in 1952's "Sinuous" and "Profile" lines, with shirtwaisters and versatile cocktail outfits. *Vogue* photographed a series of pleated crepe dresses with matching cardigans in sugar almond colors that spoke of a new easiness in his work—and which might have been aimed squarely at the huge American casual market. Shawl collars revealing acres of décolletage, chiffon layers, and floral embroidery and prints meant romance pervaded Dior's work for summer 1952, while his winter suits lent women the strong profile the collection was named for. According to *Vogue*, "Profile" demanded, "A slim high breast-line, flat diaphragm, small waist (exercises again) …"—proving that chic came at a physical cost with Dior. This point *Vogue* made explicit when they photographed the corset with "controlled hips, the nipped waist, the flat back and caved-in midriff" designed expressly to be worn beneath Dior's couture.

"Fashion in Paris, depends on the figure.
And the figure had better be good!"

VOGUE

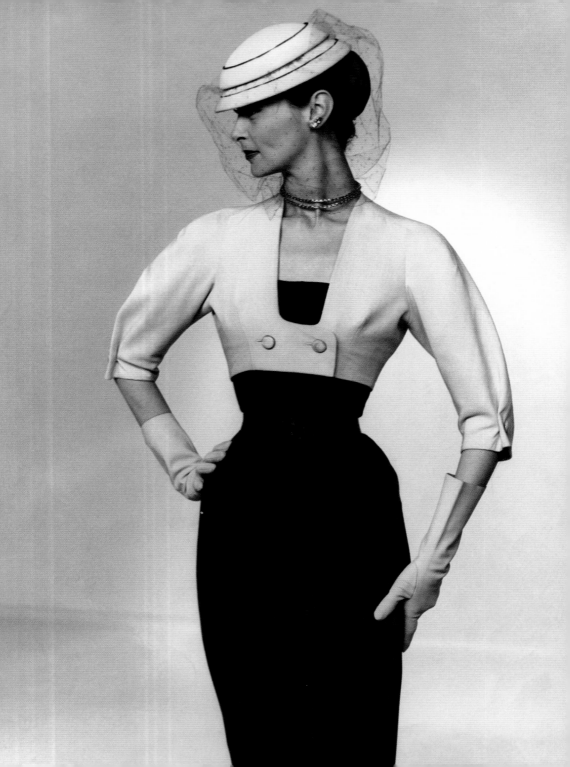

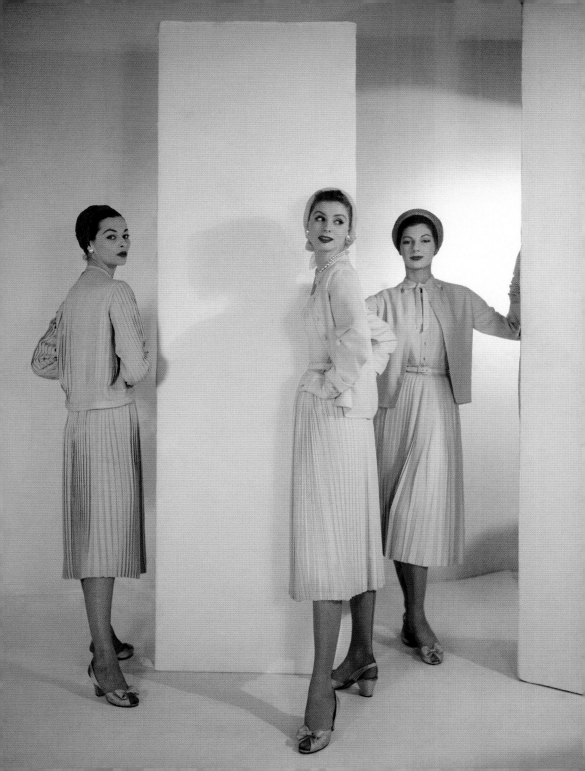

The natural world inspired Dior's "Tulip" and "Cupola" collections for 1953, not only in their flower prints, but in a new sense of suppleness. "Little by little," Dior wrote, "the waist was being freed." The Tulip made "a long stalk of a body rounding out at the bust and shoulders in petal-curved lines." Some dresses, like Dior's gray flannel "1953," boasted "nothing but a stem in body line and a rounded tulip shoulder, without a sign of a belt" reported *Vogue*.

Most newsworthy of all was the new hemline, raised sixteen inches from the ground to hit just below the knee. The controversial length was softened by a move to elevate the bust and therefore lengthen the overall line. But it still earned the sobriquet "the Shock Look" in Britain. As *Paris Match* reported, "The message was datelined Paris. It was as brief as a military communiqué: 'Christian Dior today showed his Winter Collection. Dresses stop just below the knee.' Throughout Fleet Street every Editor-in-Chief picked up his telephone and called Paris. 'Cable,' they ordered their correspondents, 'Cable the whole story. Length unlimited.' At dawn all England read the incredible news on the newspaper front pages across two, three and even four columns…"

The huge flower prints which featured on the collection's gauzy fabrics were far less inflammatory —blowsy red roses on a dinner dress called "Caracas," an evening dress covered in wildflowers and grasses, a cocktail dress sprigged with tiny roses. The botanical theme was distilled in 1954's "Lily of the Valley" collection, where dresses were, Dior noted, "Young, supple and simple, like the flower which incarnates it." His new evening dresses were designed to eliminate the need for boned corseting. As Dior explained to *Time* magazine: "How many times have I heard men complain that, while dancing, they were not able to feel the living body of women under the yoke which imprisoned them."

A 1952 "Profile" coat gives the wearer, a continuous, definitive line from neck to knee. The model in Frances McLaughlin's photograph displays the "stand-tall posture, very erect, holding in the diaphragm and pulling the breasts well up, out of the rib cage" that Vogue deemed vital for this line.

overleaf *A cocktail dress in sprigged Ascher organza for 1953's "Tulip" collection, with a hot pink coat with matching lining. Photograph by Henry Clarke.*

"I have designed flower women."

CHRISTIAN DIOR

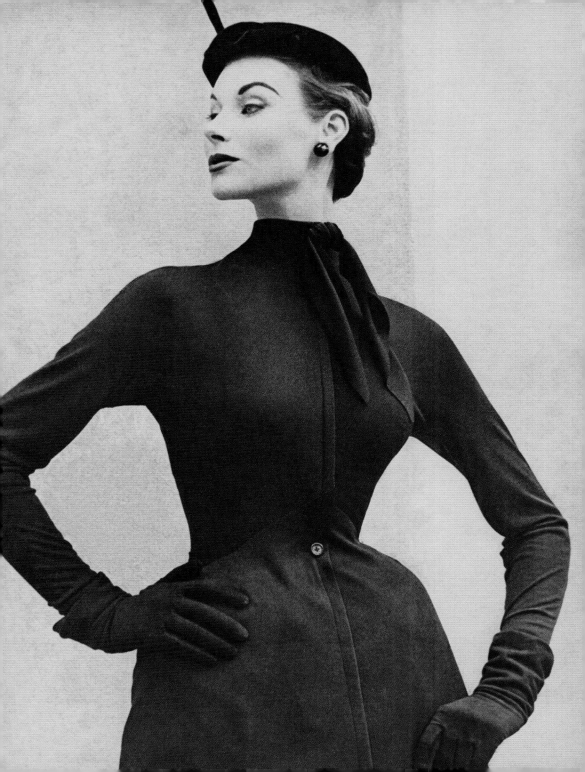

"I THINK OF MY WORK AS EPHEMERAL ARCHITECTURE, DEDICATED TO THE BEAUTY OF THE FEMALE BODY."

CHRISTIAN DIOR

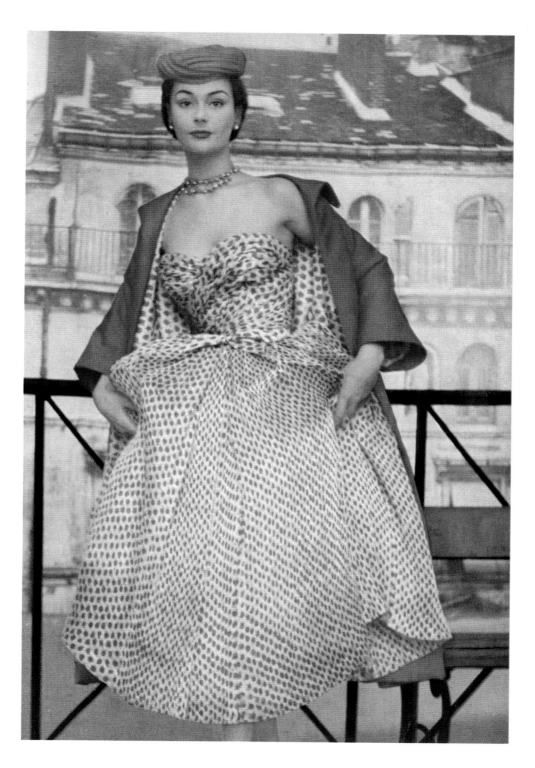

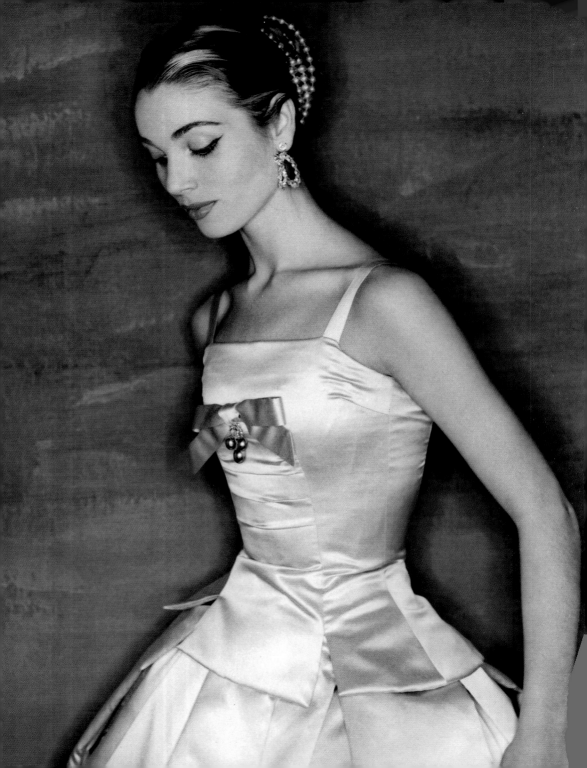

Dior's new shaping of you

A flattened bustline? You've read about it, perhaps said no

to it as unwise, unflattering. But Dior is not defying nature;

rather re-shaping it a little, perhaps beginning a great change . . .

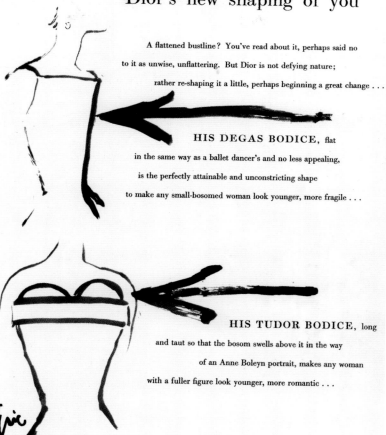

HIS DEGAS BODICE, flat

in the same way as a ballet dancer's and no less appealing,

is the perfectly attainable and unconstricting shape

to make any small-bosomed woman look younger, more fragile . . .

HIS TUDOR BODICE, long

and taut so that the bosom swells above it in the way

of an Anne Boleyn portrait, makes any woman

with a fuller figure look younger, more romantic . . .

IN OUR NEXT ISSUE

A handbag-size booklet of colour schemes, and eighteen pages

of clothes and accessories—putting into practice Vogue's tastes

in What to Wear with What this autumn . . . Furs for all finances . . .

More photographs and viewpoints from the Paris Collections

By fall 1954 Maison Christian Dior occupied "five buildings, included twenty-eight workrooms, and employed more than a thousand persons," the designer wrote. "Eight firms and sixteen allied companies spread their tentacles over five continents." Yet Dior was not averse to risk-taking. His "H" Line was the first of his alphabetical-styled silhouettes, featuring a flattened, high neck bodice atop a straight skirt or bell-shaped swell of silk organza, the cross of the H imprinted upon a low-slung waist. The bodice either pushed up the breasts—giving the wearer an Anne Boleyn look—or eliminated them completely. "A stunned audience looked on as seven years of the New Look were wiped away in a mere three hours to be replaced by the string bean look," wrote French *Elle*'s Françoise Giroud. It was, Dior recalled, "tremendously criticised, deformed and abused."

Marilyn Monroe was appalled by the "H" Line's breast-effacing effect. "I am not built for any kind of boy's fashions, so why should I wear them?" she said. American headlines blazed: "DIOR'S FLAT PROPOSALS LIKELY TO ESTRANGE BOSOM FRIENDS"; "DIOR WILL NEVER CRUSH U.S. WOMANHOOD"; "FILM BEAUTIES FIT TO BUST AT DIOR DEFLATION POLICY." *Time* reported that "no amount of patching, mending, or letting out, trimming, tacking or tucking, no gusset, gore, or gather could make last year's dress into this fall's Dior mode. In upstairs closets from Spokane to Athens, Copenhagen to Rome, millions of dresses would suddenly become 'that old thing,' their value destroyed with a swiftness and efficiency that no moth could hope to match." (Though, in reality, fewer than a third of Dior's new dresses minimized the bosom.)

Yet the "H" Line spoke of a girlish femininity that had taken root of late, the elfin kind embodied by actress Audrey Hepburn, of whom Cecil Beaton had written in *Vogue*: "Nobody ever looked like her before the Second World War; it is doubtful that anyone ever did" This "public embodiment of our new feminine ideal" gave birth to

1955's "A" Line was a welcome hit for Maison Dior. Here René Gruau illustrates a long-length jacket worn over a flaring pleated skirt—a look that the actress Olivia de Havilland chose to wear for her marriage that year to Pierre Gallant.

previous pages *An "H" Line outfit of pearl-gray satin—a bosom-binding camisole top with a notched peplum worn over a deeply pleated full skirt, photographed by Clifford Coffin. There were two ways of wearing the controversial look, Vogue reported, and Eric illustrated. The Degas bodice evoked the childlike figure of a ballet dancer, while the Tudor bodice made the bust swell "in the way of an Anne Boleyn portrait."*

thousands of imitators. As he wrote, "The woods are full of emaciated women with rat-nibbled hair and moon-pale faces."

1955's "A" line was a welcome success for the designer. *Vogue* described the silhouette as, "small head, small collar, narrow shoulders widening boldly into a tunic jacket, and still further into a skirt of swinging pleats." Coats were narrow-bosomed and flared at the hem, evening dresses—the magazine reported—seemed "to flow from shoulders to instep, lightly touching the upper part of the body and with no visible fullness or goring to make the 'A' line skirt width." It was absorbed so extensively into the marketplace, and impelled so many copies, that *Vogue* captioned a photograph thus: "Dior's A-Line suit: Bona fide Dior, this, made by Christian Dior London." But by September it was all change. The "Y" line upended the silhouette so that focus fell on the top half, on shoulders and bustline. Collars were raised around the chin, hats were high and heavy, stoles and capes were voluminous, and all worn above a lean, sinuous dress.

Nine years into his reign, Dior launched the "Arrow" line, raising the waist via high belts, bustline detail, and short swinging jackets called caracos. His winter "Magnet" line proposed empire-line dresses and cocoon coats that looked back to the age of Poiret and Proust, prompting *Vogue* to inquire: "Is it a stunt or a serious development? Should we, can we, do we want to revert to pre-emancipation femininity in the uncompromisingly emancipated era we live in?"

For his tenth anniversary as a designer, "Dior showed a collection remarkable for its wearability, for its lack of dictatorship" *Vogue* noted in 1957. The "Libre" line liberated the body from any memory of the New Look; jackets were loose, shawl-collared, skirts were straight but demi-longeur in cut and allowing for movement. Suits were "screwed to the figure subtly, their skirts expand imperceptibly which gives them a great freedom of allure," as Dior described.

But this carefully trod middle line was broken with Dior's very last collection. The "Spindle" line introduced the loose-fitting, waistless chemise-dress, or sack dress—already a Balenciaga staple—into Dior's vocabulary. It was divisive; men wrote to the couturier to complain of

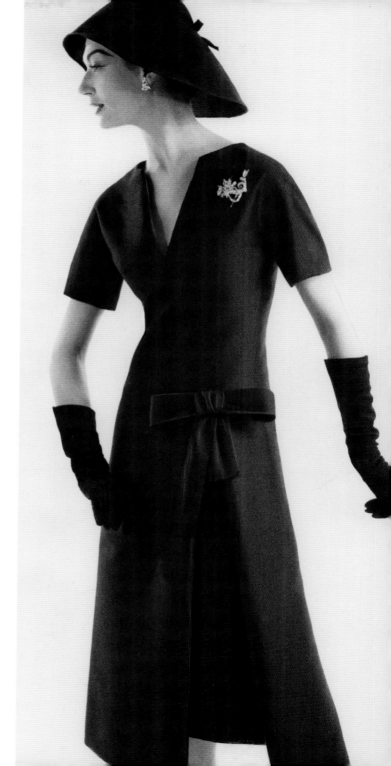

Dior's "Libre" line demonstrated in a simple shift with a noticeably looser waistline and an "A" line skirt for freedom of movement. Photograph by David Olins.

its unflattering qualities; women loved it for its power to conceal flaws. *Vogue* reported: "These are the clothes for the tall, slender woman with a flair for casual elegance and an abhorrence of any sort of fussiness in fashion." It proposed a limber silhouette and relaxed attitude that was the antithesis of the corseted and cantilevered dresses with which Dior had founded his career ten years previously.

But if Christian Dior had come a long way, so had the Paris fashion industry. The late Forties and Fifties were, in some respects, a golden age for haute couture, with the houses of Balenciaga, Fath, Desses, Worth, and Chanel propelling French elegance into the wider world. "Charming in several languages," Pierre Balmain—Dior's old work colleague at Lucien Lelong—was, according to *Time* magazine, "The man who claims the largest private clientele in all Paris." The 79-inch Count Hubert Taffin de Givenchy proposed lines with daring colors and unusual fabrics; while under the auspices of Jeanne Lanvin's successor, the Spaniard Antonio Castello, Lanvin-Castello incorporated exoticism into his wearable collections.

Dior's influence meant that couturiers could no longer rely on making slow and incremental changes to their aesthetic; and many designers capitulated not only to Dior's fast-paced regime, but also to the dominance of his silhouette, promulgating their own versions of the New Look. Naturally there were exceptions, such as Chanel, who refused to play Dior's game of seasonal novelty. "Chanel is the fascinating paradox – the couturiere who takes no account of fashion," *Vogue* observed, "who pursues her own faultlessly elegant line in the quiet confidence that fashion will come back to her – and sure enough it always does." And Balenciaga, of whom Cecil Beaton observed: "Balenciaga belongs to no clique, plays nobody's game but his own, steadfastly refuses to commercialize either himself or his talents, pays little attention to the seasonal changes of styles and pursues a solitary creation of values. He is so much the opposite of a Christian Dior that they might well be placed at the far ends of the dressmaking world."

A sack or chemise-dress from Dior's "Spindle" collection. Described here by Vogue *as "slim and loose as a nightshirt," the dress, photographed by William Klein in the center of Paris, marked Dior's most radical move away from the New Look silhouette. It was his last collection.*

They respected each other: Dior humbly acknowledged, "Haute couture is like an orchestra, whose conductor is Balenciaga. We other couturiers are the musicians and we follow the directions he gives." Where Dior imposed rigor upon a woman's body, augmenting her silhouette via corsetry, Balenciaga worked with the body itself, artfully disguising its flaws via subtle cutting techniques. In 1955 *Vogue* noted a "significant struggle" between these two modes of couture. On one side were designers like Dior, Givenchy, Fath, and Balmain "whose achievement is to create clothes: clothes of so strong a shape that they look as if they could walk across the room alone. These are clothes with 'hanger appeal' and a consequent appeal to the wholesale manufacturer and the store." On the other side were the designers—Balenciaga and Chanel—who dressed women. "These clothes are not superimposed on a body; they have to be worn. When they move one is conscious of the body beneath and they have no existence apart from it. One might not look twice at them on a hanger, and they are much more difficult to translate into ready-to-wear terms."

A model is fitted for a Lefaucheur corset in Dior's atelier in 1952. Such a corset, Vogue reported, lent a woman the required Dior shape: controlled hips, nipped waist, flat back, and caved-in midriff. Photograph by Frances McLaughlin.

But the different ways of dressing offered by haute couture only served to imbue the postwar Paris fashion scene with interest and glamour. Haute couture, in the first half of the new decade, was thriving. Spearheading the boom was undoubtedly Dior, whose Avenue Montaigne salon had earned the status of a Paris landmark. Inside the house, the couturier ruled with kindness and proceeded with charm. (An attitude exemplified by the way he once complained of a curt manager: "Not only will he lose his credibility, he'll lose his position and his function. They must feel fond of him.") He took a *paterfamilias* approach with his staff; annual fetes and fancy dress parties were encouraged in the ateliers, he defended his *rendeuses* against tyrant clients, and indulged his favorite models. On St. Catherine's day, the traditional celebration of all unmarried women over twenty-five, Dior threw a party for his staff on the first platform of the Eiffel Tower.

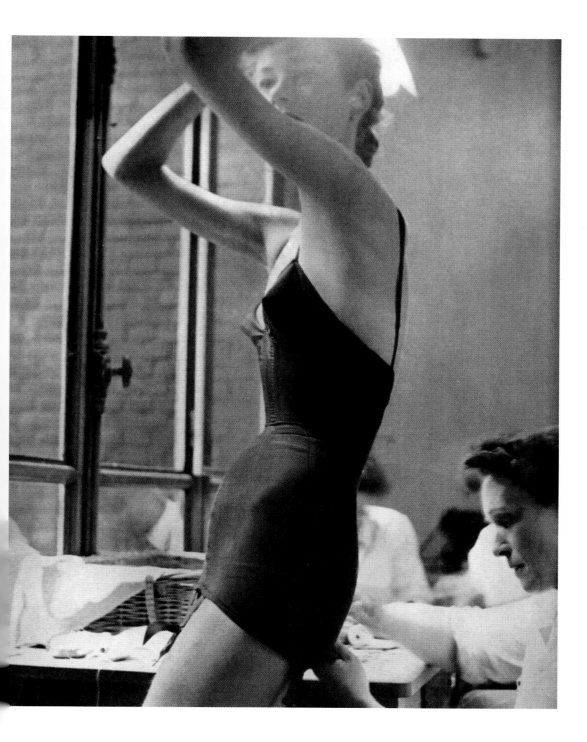

VOGUE

Christmas Number

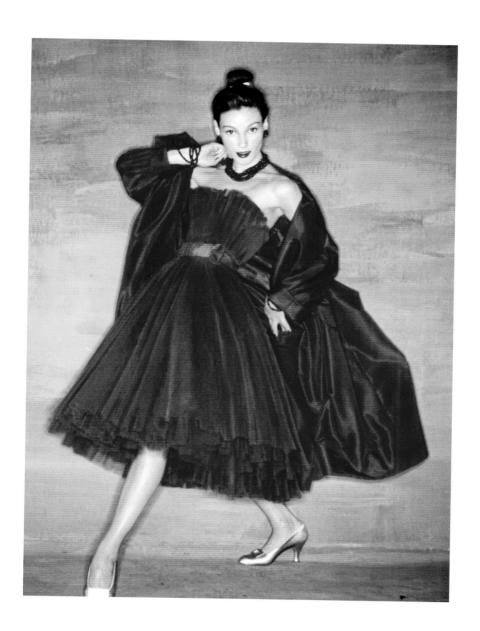

He had unremittingly high standards for himself as well as his employees. "It is true that I am demanding: but who is not, in pursuit of the realization of his dreams?" Thus he was quick to temper if those standards were not met; his acute perfectionism meant he could and would erupt into a fury if things weren't exactly to his liking. Manners were everything—Dior once refused to conduct a conversation with a man who was without collar and tie; a girl was ejected from his office for chewing gum. When a model confessed she hated the dress she was wearing, Dior was furious. "By making fun of that dress, this young lady was making fun of all the people who made it. That is something I can't accept!" he said. He felt, heavily, the responsibility of caring for the hundreds of people who worked for him, an undertaking that added to the stress and anxiety already heaped upon his workload.

In the eye of the storm: Dior is surrounded by his models being prepared for a show in a perfumed frenzy of ball gowns, sequins, and high heels.

previous pages Dramatic in red: Dior on the cover of Vogue, December 1954. Photograph by Clifford Coffin.

And it was quite a workload. By 1957 Dior was sitting on a fashion empire, the head of a complex network of licenses and business arrangements that span out across the globe from his Paris couture house like silk threads from a spider's web. His couture collections were the distilled essence of his ideas and ideals. But it was his business ventures that gave the house of Dior its enduring legacy.

"Dior is that nimble genius unique
to our age with the magical name –
combining God and gold {dieu et or]."

JEAN COCTEAU

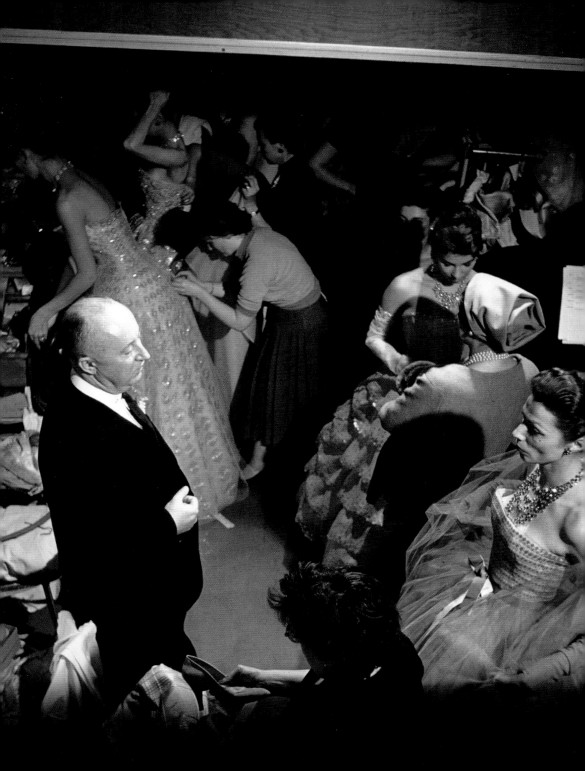

"THE NAME OF DIOR CAN SELL ANYTHING AND DOES."

BETTINA BALLARD

COMPLETELY DIOR

THE VERY NOTION OF HAUTE COUTURE is founded on elitism, its elevated status evident even in its name—haute couture. In an industry which produces bespoke clothing in the service of a privileged few, it is all the more remarkable that a couturier ended up dressing the world. Captured and disseminated by a powerful media, Dior's full-skirt-nipped-waist silhouette was the pervasive postwar look, worn by everyone from aristocratic grandes dames to American teenagers (that newly discovered species who teamed their swinging skirts with bobby socks and pony tails). But Dior's intention had never been to design for everyone. Quite the opposite. He had declared to Marcel Boussac in 1946 that the house of Dior should cater only to "a clientele of really elegant women." That he was able to create ball gowns for the Duchess of Windsor, while contemporaneously signing his name to stockings, men's ties, perfume, gloves, jewelry, handbags, and furs is a mark of how successfully Dior fused the distinct worlds of commerce and couture.

Hat, gloves, cigarette, and champagne: modeling Dior's accessories and lifestyle for Vogue, *December 1957. Photograph by Henry Clarke.*

overleaf *Christian Dior and Mitzah Bricard selecting ties to be sold as Dior accessories (left). Parfums Christian Dior at the Dior boutique (right).*

Dior's business nous developed at breakneck speed. On the advice of his financial director Jacques Rouet, the couturier signed a deal to create Parfums Christian Dior a mere eight months after his debut. Understanding the need for haute couture to adapt to the American market, in October 1948 he founded Christian Dior New York, a Fifth Avenue store which sold ready-to-wear lines designed specifically for the American woman. *Time* magazine wrote, "The dresses will be a 'conservative evolution' of his Paris models, designed with one eye on the US tastes and the other on the limitations of machine production." In that same month he opened Christian Dior Furs and a millinery department in Paris. By 1949 he had signed his first license contract —the first couturier ever to have done so—for a range of stockings.

Corset-makers, jewelers, and furriers beat a path to Avenue Montaigne. Guided by Rouet, Dior exchanged one-off fees for a cut of the royalties, ensuring a constant revenue stream for the house.

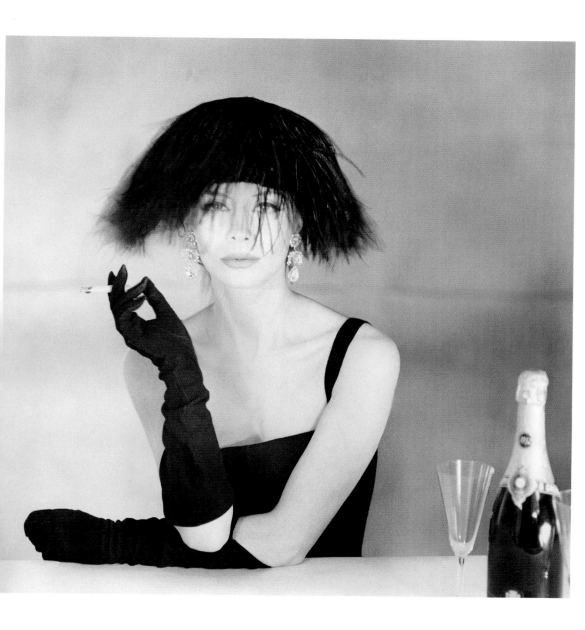

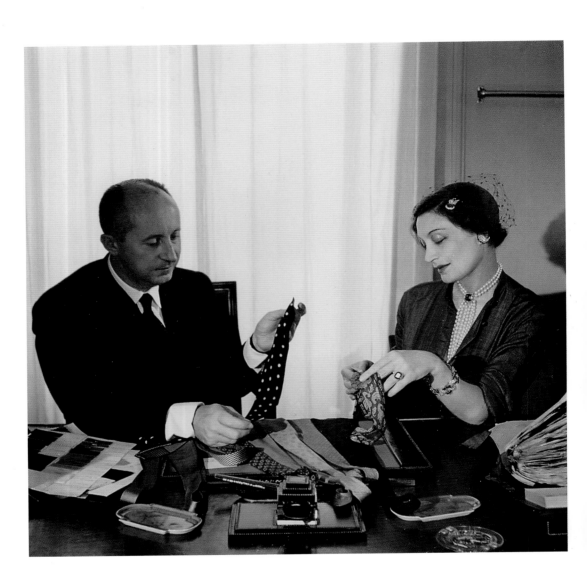

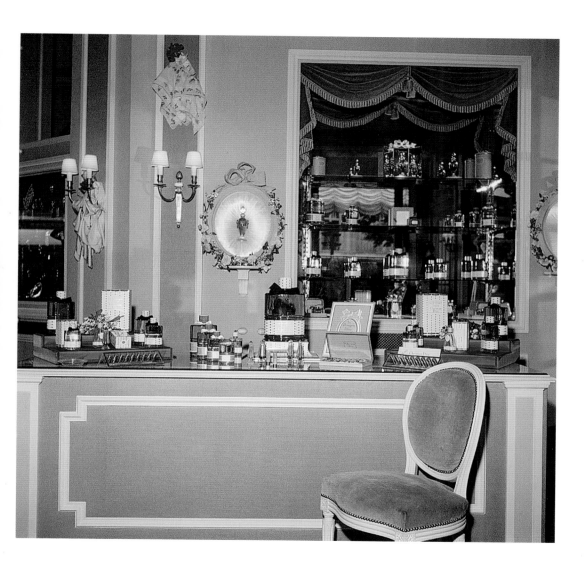

Such was the pace and volume of these new export, wholesale, and licensing agreements, that in 1950 Dior set up a specific department to marshal his business ventures. In the same year, the output from Maison Christian Dior equaled more than half the total export profits for the entire Paris couture industry. Dior was awarded the *Legion d'Honneur* by the Ministry of Trade and Commerce in recognition of his contribution. By 1957, Maison Dior had established licenses in 87 countries—from Canada to Cuba, America to Australia.

Behind "their facades of perfumes, of organdie and mannequins"— as Dior stressed to Cecil Beaton—couture houses "were commercial enterprises where the least yard of *mousseline* [muslin] becomes a figure on a page, where the collections of each season become the francs and the sous of hundreds of employees who cater to that amorphous monster, the general public of women." The world of couture might, in the public eye, appear frivolous, but its foundations were built on rigorous financial calculation. "I risk the salary of nine hundred persons in making a collection," Dior told Beaton.

An example of René Gruau's characteristically glamorous drawings for Dior's advertisement campaigns; here Gruau appropriates couture's patrician elegance to sell Diorama perfume.

Unsurprisingly, then, Dior approached the building of his empire with the same strict framework that he brought to his clothes, a carefully stratified architecture that included couture at its apex, and a pair of Dior-label stockings at its base. In such process he created the model for the modern fashion house, where the majority of a designer's profits are rendered by ancillary products: handbags, sunglasses, makeup, and perfume. Dior was selling a romantic concept of Paris couture with its attendant murmur of wealth and privilege, a dream which now everyone could buy into.

"A woman's perfume tells more
about her than her handwriting."

CHRISTIAN DIOR

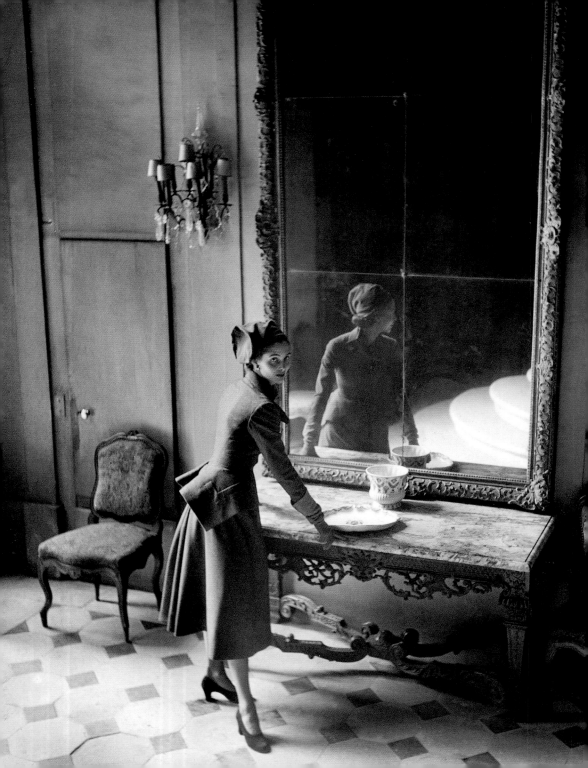

And why shouldn't haute couture and perfume be two sides of the same coin? Or, even, reflect two sides of the same man? "It was true that I was a French couturier, but I had to understand the needs of elegant women all over the world as well as my fellow countrywomen," as Dior wrote in his memoirs. He considered it an extension of good manners, (and excellent business sense), that every woman should be able to glean a little Dior magic. "Dior never forgot his customers," wrote Bettina Ballard, "the commercial ones, the private ones, and even the out-and-out copyists."

Papered with toile de Jouy, perfumed with Miss Dior, the Paris boutique was a scale model of this vast enterprise. *Vogue* described a July 1955 visit in whimsical terms: "The Dior boutique at 30 Avenue Montaigne is crammed with a lot of lovely small items – scarves, stockings, handkerchiefs, tiny pieces of jewellery, which make delightful presents at a reasonably modest cost, as well as the heavenly semi-couture clothes (one fitting, or alterations if necessary)." There were shoes too, by Dior's in-house shoemaker, Roger Vivier, available both ready-made and bespoke. "I wanted a woman to be able to leave the boutique dressed by it from head to foot, even carrying a present for her husband in her hand," Dior wrote. "All the activities which were now associated with my name, were to be found within these walls of the boutique: the stockings, gloves, and perfumes, whose rise to fame has been parallel to that of my house itself."

A model rests in front of a mirror in a Dior gray flannel suit with full-back skirt, photographed by Clifford Coffin for Vogue, *October 1948. Even as his line trickled down to stockings, ties, and fragrance, Dior's appeal rested upon the kind of refined image encapsulated here.*

overleaf A lean-cut dress from Dior's "Long" line is completed with a fur muff and matching fur-lined coat and hat, each element of the outfit conceived by Dior. Photograph Henry Clarke.

In the postwar world of conspicuous consumption, of advertising and Cadillacs, washing machines and jet planes, Dior's timing was perfect. Women rushed to his Paris boutique, the pleasure of a visit derived in browsing its wares as much as in the thrill of bearing home a small gray Dior box, tied with white ribbon. The soothing, scented atmosphere of the boutique stood in contrast to the frenzy of professional buying after each season's show. Twice a year, Paris was flooded with Americans, as *Time* magazine's Stanley Karnow recalled.

"IN FRONT OF THE MIRROR, SURVEYING THE FINAL RESULT, THERE YOU WERE, COMPLETE: COMPLETELY DIOR TOO!"

OLIVIA DE HAVILLAND

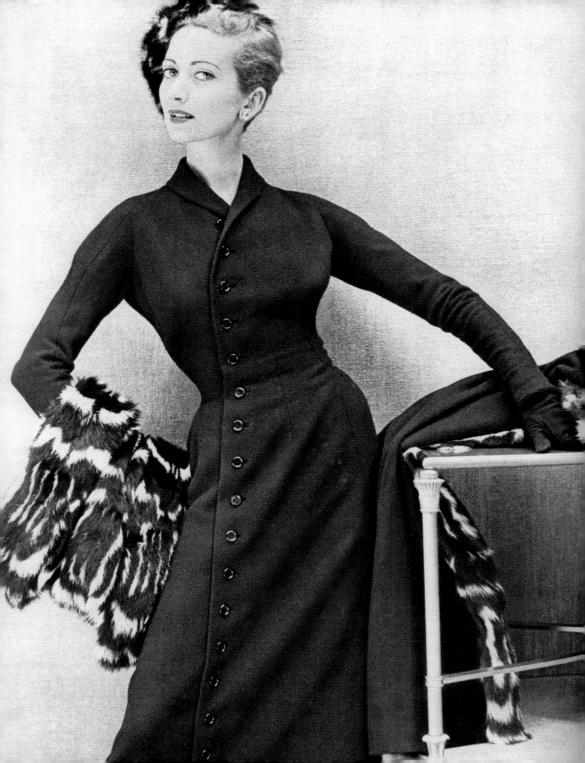

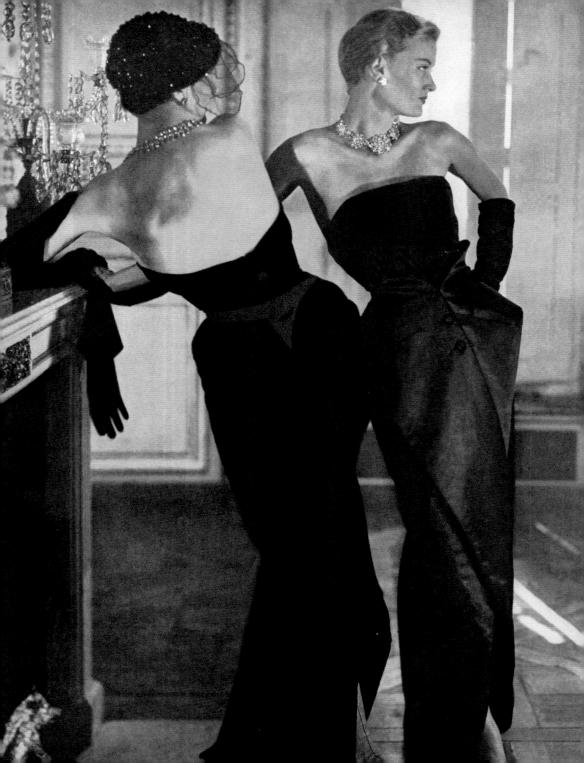

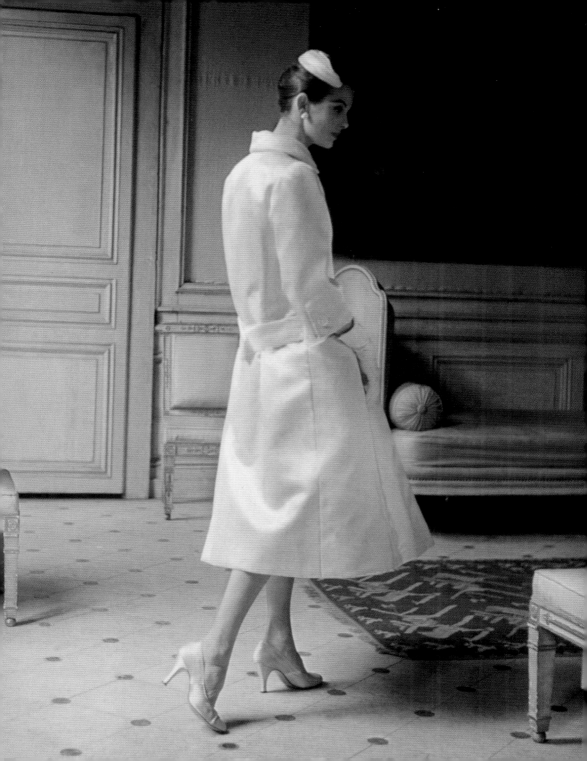

"In the district around the Champs-Elysées, the George V. Prince de Galles and Plaza Athénée lounges were shrill with the shouts of Chicago and Dallas department-store buyers as they cruised from divan to divan, hailing California and Florida dress-chair representatives. At plush restaurants like Lasserre, Ledoyen and Maxim's, stocky, cigar-chomping Seventh Avenue manufacturers in silver ties and white-on-white shirts shared tables with New York designers in jangly bracelets and rhinestone-rimmed glasses."

This was the moment that Dior's clothes ceased to be his "children" and became "objects of commercial value," the couturier wrote. Representatives of department stores around the world paid large deposits for their seats in Dior's salon, (a safeguard against plagiarism and time-wasters), which were arranged by strict protocol. (An obscured view was a *vendeuse's* revenge for a low order on a past collection.) The couturier's new line was viewed by this poker-faced pack, then "probed minutely for hours," recalled Dior. The clothes were "measured, turned inside out, unstitched, sometimes literally pulled to pieces, in order that they may yield up their secrets. We are lucky if buttons and embroideries are not torn off as samples or souvenirs."

Some *modeles* were ordered in large quantities to sell, some were bought individually to be copied by a department store's own dressmakers. A wholesaler might purchase the rights to Dior's designs —for two thousand dollars and a cut of the royalties—to turn out dresses for fifty dollars (in today's prices, approximately $400); thus enabling "an Atlanta stenographer or a Cleveland nurse," with a little sacrifice, to emulate a chic Parisienne. Karnow recalled, "buyers for Henri Bendel, Saks, I. Magnin, Bonwit Teller, Neiman-Marcus and other establishments that catered to the carriage trade huddled with the solemn, black-clad vendeuses strategically stationed in the corridors. Every buyer had her personal *vendeuse*, every *vendeuse* her jealously coveted clientele – and, after years of making deals, they

trusted each other. Some buyers, enraptured by the models they had just seen, instantly signed contracts, but most of them would shop around and deliberate before deciding. With big bucks at stake, the risks were enormous. An item that glittered in scintillating Paris could bomb in sober Scarsdale."

Dior did not shy away from this visceral end of the couture business. "I concern myself personally with the prices," he wrote. "Every model is the subject of a detailed dossier, stating the hours of work spent on it, the cost of the work done by hand, and the price of the material. By adding to this a percentage of the overheads, taxes, and the necessary amount of profit, one gets a very good idea of the price at which the dresses ought to be sold." He did not miss a thing, as Bettina Ballard noted: "[Dior was] always aware when a customer had complained about a dress not fitting, when a buyer complained about a price, when a fashion magazine photographed too many models that they didn't print, when a mannequin had a broken heart, and exactly how many models his best customers ordered." Such hawk-eyed scrutiny extended to his market place too, meaning that in each new line, as *Vogue* observed in 1957, there was "always something for everybody."

A red cupola coat by Dior on the cover of Vogue, January 1955, *sketched by René Bouché.*

D ior took an equally direct approach with the press. Unlike Cristobal Balenciaga, who remained hermetically sealed against all and any press intrusion, Dior's publicity department was "the most obliging in Paris, making it possible for pictures of Dior clothes to be the best and the most plentiful in the press," as Bettina Ballard wrote. To say that Dior recognized the importance of the press is an understatement. He even went so far as to write, "The relationship of a couturier with the Press is like a love affair – a never-ending love affair, renewed each season, involving endless intrigues and reconciliation."

He did not understand those designers who spurned publicity. "The French couturier tends to blame the press for indiscretions and bringing down the value of the models. In my opinion he is wrong to do so because the picture of a dress in a magazine can inspire a woman to buy it." (As well might comment the man vaunted by *Time*

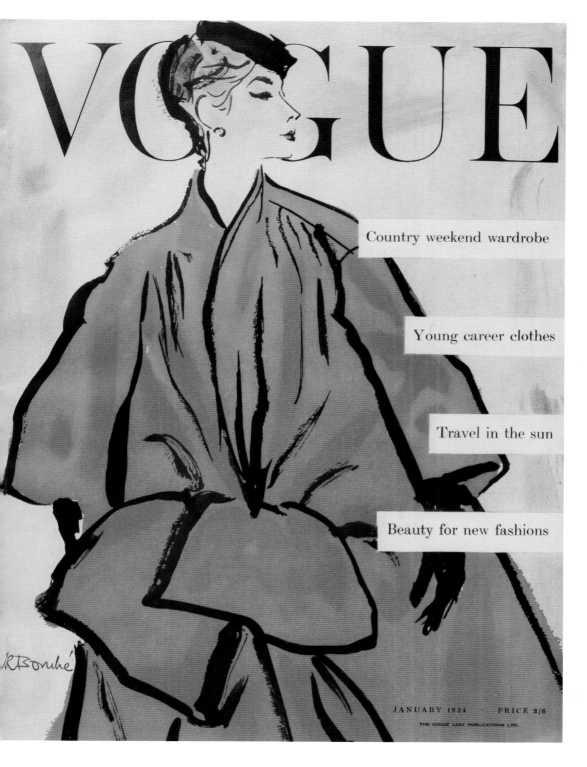

VOGUE

Country weekend wardrobe

Young career clothes

Travel in the sun

Beauty for new fashions

JANUARY 1954 · PRICE 3/6

THE CONDÉ NAST PUBLICATIONS LTD.

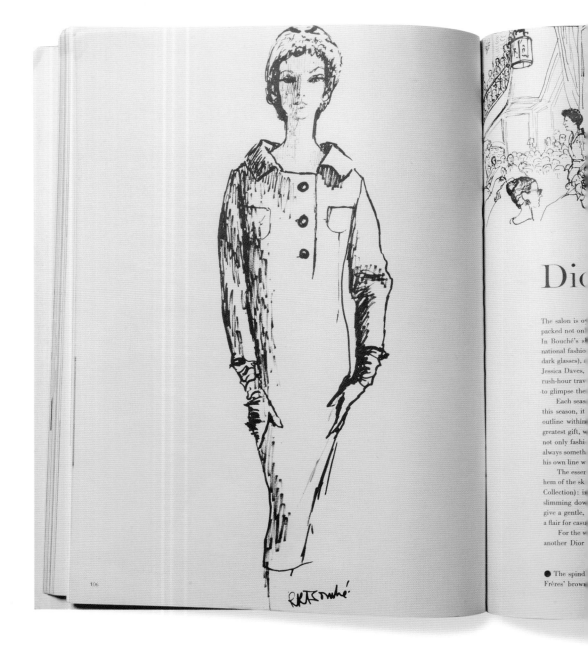

RBKBouché

l white, lofty and luxurious and—for his first showing of the season—jam-
but with tangible excitement, a tingling anticipation and sense of occasion.
Dior's *directrice*, Mme. Luling, walks between the serried ranks of inter-
foreground, Mlle. Edmonde Charles-Roux, the Editor of French Vogue (in
ht, Mrs. Cathy McManus, one of American Vogue's fashion editors, and Miss
merican Vogue. On the steep staircase, *vendeuses* and *midinettes* swarm like
scalator—or like back-stage workers peeping anxiously through the curtains
a critical first-night audience.

his Collection with a sharply descriptive symbol—an A, a magnet, an arrow:
This quick, visually-evocative summary indicates the framework, the rough
as elected to work: but any such rigid symbolism takes no account of his
liant, loving facility for making a woman look not only elegant but beautiful;
ppealing. Within the limits of basic shape which he sets for himself, there is
ody—and his last few Collections have shown a growing tendency to interpret
edom and variety.

dle line is ease: a neat head, an undefined waist, and a narrowing towards the
est form, it appears in curving top coats (there's not a fitted coat in the whole
s adapted to make beautifully casual waistless sheaths, often bloused, and
vness below hip-level: for late-day, thigh-long jackets with low-set sash belts
r straight, slim skirts. These are the clothes for the tall, slender woman with
ad an abhorrence of any sort of fussiness in fashion.

ves romanticism, who is proud of her small-waisted, curvaceous figure, there's
ap of late-day dresses with the dangerously-plunging *décolletages*, the tiny

upremely simple dress (available at Harrods in late September) of Dormeuil
e tweed. The small cloche hat (also by Dior) is made of pintade feathers

"THE RELATIONSHIP OF A COUTURIER WITH THE PRESS IS LIKE A LOVE AFFAIR — A NEVER-ENDING LOVE AFFAIR, RENEWED EACH SEASON, INVOLVING ENDLESS INTRIGUES AND RECONCILIATION."

CHRISTIAN DIOR

Vogue *pages, September 1957, sketched by Bouché,
reveal how Dior's collections were reported.* Vogue
*writes of the "tangible excitement, a tingling
anticipation" that fills the salon moments before
Dior's new line was revealed.*

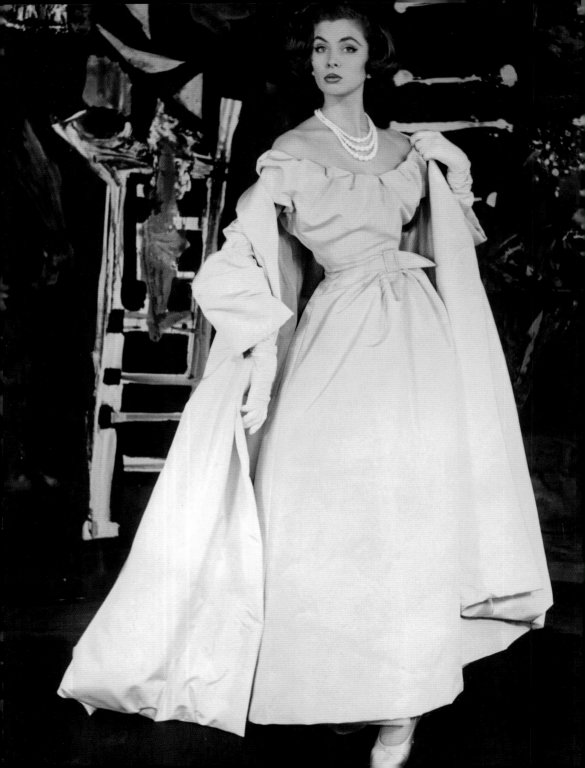

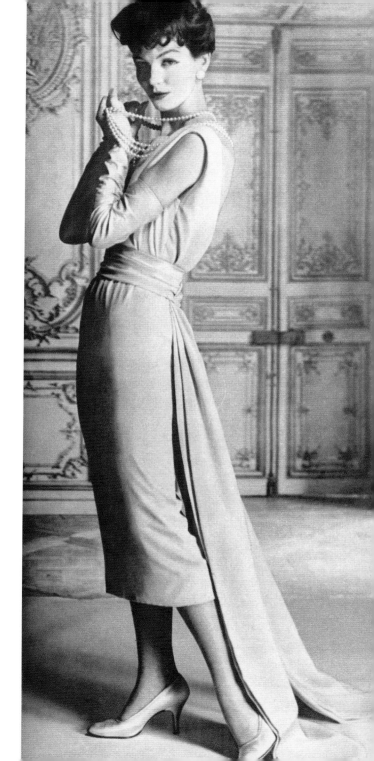

"I BROUGHT BACK THE NEGLECTED ART OF PLEASING."

CHRISTIAN DIOR

Dior desired his collections to be worn by "a clientele of really elegant women," as reflected in photographs taken for Vogue *by Henry Clarke in 1954. Shown left is a stiff white faille Dior ball gown with matching opera coat and, right, clutching a string of pearls, a model wears a cocktail dress with twin train.*

magazine as "Atlas, holding up the entire French fashion industry.") The press was a powerful force. As Carmel Snow told *Time* in 1947, "The editors must recognize fashions while they are still a thing of the future. The dressmakers create them, but without these magazines, the fashions would never be established or accepted."

Not only did Dior engage with the press, he also bent it to his needs. "Nothing was left to chance," as Ballard observed. "The new, the newsy, the fashion excitement were pointed out clearly in polished program notes that Dior wrote himself, graphically describing the 'H' line, the 'A' line, or whatever it was that he was pointing up that season so that there was no particular skill necessary to report on a Dior collection." It was as close as the couturier could get to writing his own reviews. Of course, such an accommodating attitude had its drawbacks. As Ballard related: "I remember the summer of 1955 when [Dior's] desire to please reached such heights that it was impossible to pass a street corner within walking distance of Dior's for the weeks following the opening without seeing Japanese, Scandinavian, Italian, American, German, English, and various South American photographers and reporters snapping pictures of mannequins in exaggerated inhuman poses wearing Dior's dresses."

Diva in Dior: Josephine Baker is resplendent on stage in a couture evening gown. Photograph by Alfred Eisenstaedt.

Few couturiers were interviewed by Edward Murrow for CBS, nor photographed for magazine covers around the world; fewer still published not one but two memoirs—*Je suis couturier* in 1951 and *Dior by Dior* in 1956. As Christian Lacroix recalled of Dior, "He was so famous in France at the time. It seemed as if he wasn't a man, but an institution." And not only famous in Europe: a US Gallup poll named Dior one of the five best-known international celebrities. As he recalled, "If one measures the popularity of a star by the fan mail she receives, then I ought to have been considered a celebrity indeed. Letters arrived by the thousand – mostly enthusiastic but sometimes indignant." This mail—from Australia, Florida, Germany, Italy, and Japan—"included letters from madmen, criminals, megalomaniacs, geniuses, [calling] him in turn madman, a criminal, a megalomaniac, a genius, a grand vizier, an emperor, or a dictator of fashion."

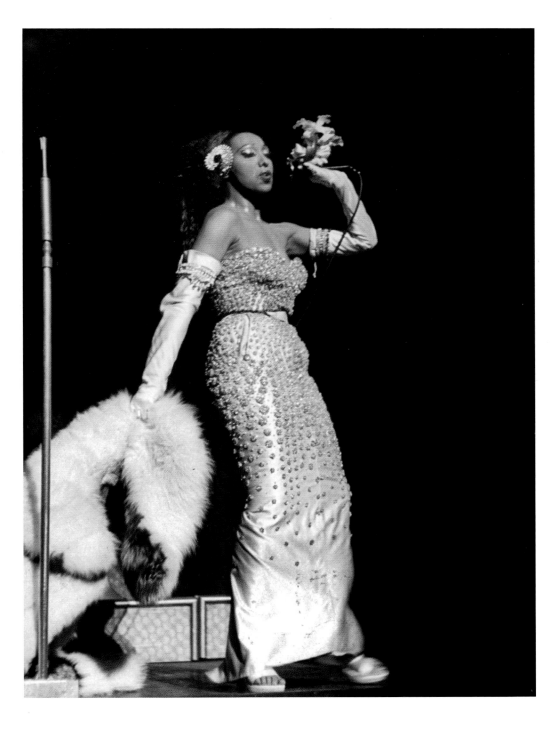

Images of Dior's designs proliferated in newspapers and magazines, and—a consequence of the twentieth century boom in photography—came courtesy of Horst, Richard Avedon, Henri Cartier-Bresson, Robert Doisneau, Irving Penn, Inge Morath, and, even, war photographer Robert Capa. Photographed in elegant salons, in front of Paris landmarks or against black backdrops, his designs modeled by the most beautiful women in the world, these images engendered a worldwide perception of Dior's couture, and the Dior world, as a kind of pure glamour. As did René Gruau's illustrations for the couturier's product ranges—a white swan, its neck looped with a black ribbon and pearls, for the fragrance Miss Dior; a woman's hand resting on a leopard's paw, also for Miss Dior. Sexy as a flick of eyeliner, Gruau's sinuous black-line drawings supplied the house a visual signature as distinctive as its gray and white color scheme. It was a form of image control that foreshadowed the advertising campaigns and marketing strategies of today's designers.

René Gruau's sensuous surrealism for the Miss Dior perfume advertisement.

overleaf Dior's clothes seemed to require a certain lifestyle, not least a certain income (left). Here, a 1950 Norman Parkinson photograph depicts a model in a tiered ball gown, pictured in an aristocratic setting. Dior was uniquely obliging to the press (right): he even wrote program notes to accompany his own collections, directing journalists to his new silhouette. Dior's show notes from his debut spring 1947 collection reveal New Look's intentions: clothes "typically feminine and made to flatter their wearer."

At source, this imagery traded on the notional magic of couture itself. A large part of that magic lay in the fact that couture serviced the most elegant—and the richest—women in the world. Dior's clients imbued the house with a palpable glamour, introducing that particular tenor of excitement derived from proximity to money and celebrity. Among those who sat readied with paper and pen at each Dior presentation, were socialites and aristocrats like the Duchess of Windsor, Princess Margaret, Liliane de Rothschild, Eugenia Niarchos, Eva Peron, Gloria Guinness and her daughter Dolores, actresses Ava Gardner, Rita Hayworth, Ingrid Bergman, Gina Lollobrigida and Jane Russell, prima ballerina Margot Fonteyn, dancer Josephine Baker, and opera singer Maria Callas. One could not watch a movie in the 1950s without seeing a Dior-look full skirt—as on Grace Kelly in *Rear Window*—or a Dior-look pencil skirt and nipped jacket suit—as on Lauren Bacall, in *How to Marry a Millionaire*.

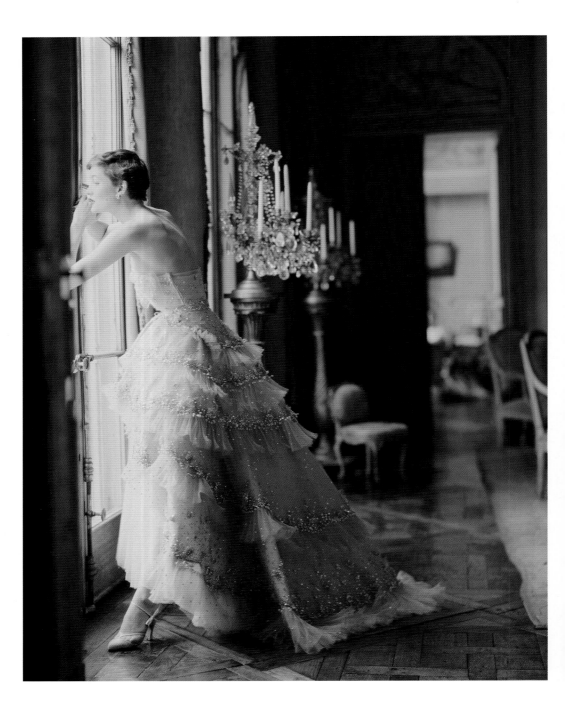

Christian Dior

COLLECTION PRINTEMPS 1947

———

Les lignes de cette Première Collection de Printemps sont typiquement féminines et faites pour mettre en valeur celles qui les portent.

2 Silhouettes principales :

La silhouette " COROLLE " et la silhouette en " 8 "

" COROLLE " : dansante, très juponnante, buste moulé et taille fine.

" 8 " : nette et galbée, gorge soulignée, taille creusée, hanches accentuées.

Les jupes allongées nettement, les tailles marquées, les basques de jaquettes souvent écourtées, tout contribue à élancer la silhouette.

Seules les robes de fin de journée ou de grand soir sont largement et doucement décolletées.

L'asymétrie, le trop grand emploi du drapé et l'entrave ont été volontairement évités.

Coloris dominants : Marine - Gris - Grège et Noir.

Quelques teintes discrètes : Royal kaki.
Bleu de Paris.
Terre de Paris.

Quelques tons éclatants : Rouge Scream.
Vert Longchamp.
Rose Porcelaine.

Imprimés exclusifs : Pois et carrés sur twills de teintes discrètes.
Imprimé " Jungle " sur crêpe et mousseline.

Les chapeaux volontairement simples, précisent la silhouette voulue.

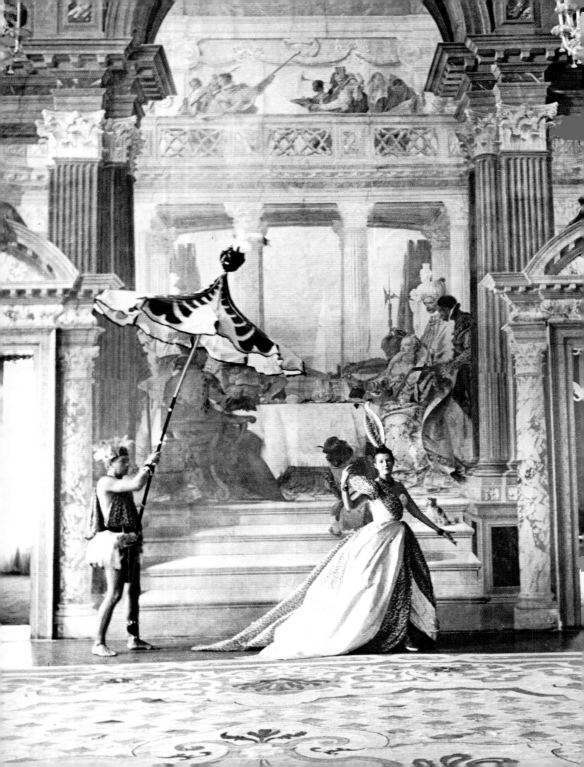

(Bacall was photographed attending a Dior show seated next to her husband, Humphrey Bogart. It's impossible to assess whether Dior's fashions, or Bogart's natural disposition, were responsible for the actor's lugubrious expression).

Dior's couture accounted for a specific lifestyle, one that required a certain elegance and deportment, a nightlife of balls and cocktail parties, banquets, and fetes. In 1951 he dressed socialite and style maven Daisy Fellowes, *Harper's Bazaar*'s Paris editor, as the Queen of Africa for Le Bal Oriental held at the Palazzo Labia in Venice. In attendance that night were Lady Diana Cooper, heiress Barbara Hutton, the Aga Khan III, Salvador and Gala Dali, and the Duchess of Devonshire. A guest recalled witnessing a cavalcade of chauffeured Rolls Royces charging through the Alps to Venice, each with a pile of Dior boxes strapped to their roofs.

Daisy Fellowes, dressed by Dior for Le Bal Oriental, and photographed by Cecil Beaton. She was described by Baron de Rede as "by far the most elegant person at that ball."

Dior made the singer Edith Piaf's wedding gown; it was a copy of a chiffon gown he'd made for her friend, Marlene Dietrich, whom Dior had dressed in *No Highway*. He dressed left-bank troubadour Juliette Greco. He dressed Margot Fonteyn, who wrote, "I was lucky enough to be more or less the same size as one of his favourite models, Vicky, and at the end of each season I was able to buy one of the model dresses made on her." Princess Margaret, whom Dior described as "a real fairy princess, delicate, graceful, exquisite," visited Dior's Paris salon to be fitted for a couture gown for her twenty-first birthday. "I found that she was keenly interested in fashion, and also, unlike many women, knew exactly the sort of fashions which suited her fragile height and Titania-like figure," he wrote. Rare was the woman of fame, privilege, and taste in the late 1940s and 1950s, who did not own at least one piece of Dior couture. As fashion historian Katell le Bourhis said of the Duchess of Windsor, "[her] whole life was about finding something to do, and most of the time that meant going to 30 Avenue Montaigne."

Dior told Cecil Beaton how he divided his clients into categories: "the woman who is insane for dresses; the woman who is never contented; the woman who does not know what she wants; and the perfect client, who knows what she wants and how much she can pay for it."

"I WAS A FRENCH COUTURIER, BUT I HAD TO UNDERSTAND THE NEEDS OF ELEGANT WOMEN ALL OVER THE WORLD."

CHRISTIAN DIOR

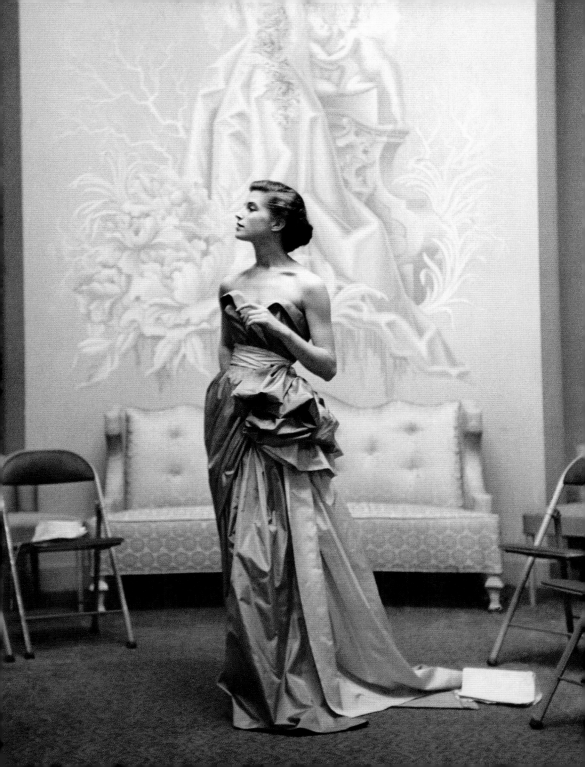

Christian Dior

présente

" Miss Dior "

son premier parfum

Exclusivement en son Hôtel, 30 Avenue Montaigne
à partir du 17 Decembre 1947.

An invitation to the launch of the
couturier's debut fragrance, Miss Dior,
December 17, 1947 (above).
A Cinderella in Dior's "Adelaide" ball
gown (composed of 230 feet of tulle) and
silk opera coat, on the steps of the Paris
Opera (right). Photograph by Clifford
Coffin, April 1948.

previous page A picture of elegance: a
society patroness in Dior, photographed
by Wayne Miller for Vogue at a San
Francisco benefit, 1950.

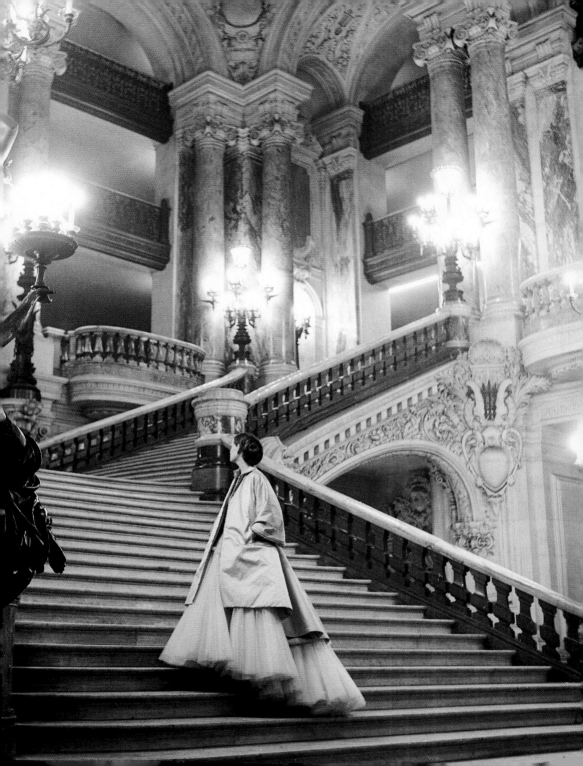

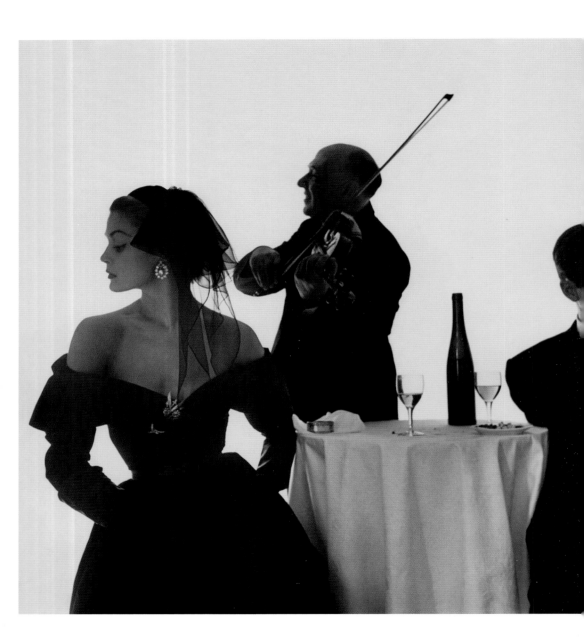

"WHEN I OPENED MY COUTURE HOUSE I DECIDED TO DRESS ONLY THE MOST FASHIONABLE WOMEN FROM THE FIRST RANKS OF SOCIETY."

CHRISTIAN DIOR

"THERE IS NOTHING I WOULD LIKE BETTER THAN TO MAKE EVERY WOMAN LOOK AND FEEL LIKE A DUCHESS."

CHRISTIAN DIOR

The Duchess of Windsor photographed by Cecil Beaton, dressed by Dior, 1951 (left). "The Duchess's whole life was about finding something to do, and most of the time that meant going to 30 Avenue Montaigne," said historian Katell le Bourhis.
Hollywood royalty in the front row: Lauren Bacall and Humphrey Bogart at Dior, 1952 (right).

previous page *Music, romance, and haute couture: Irving Penn captures a life in Dior for* Vogue, *October 1949.*

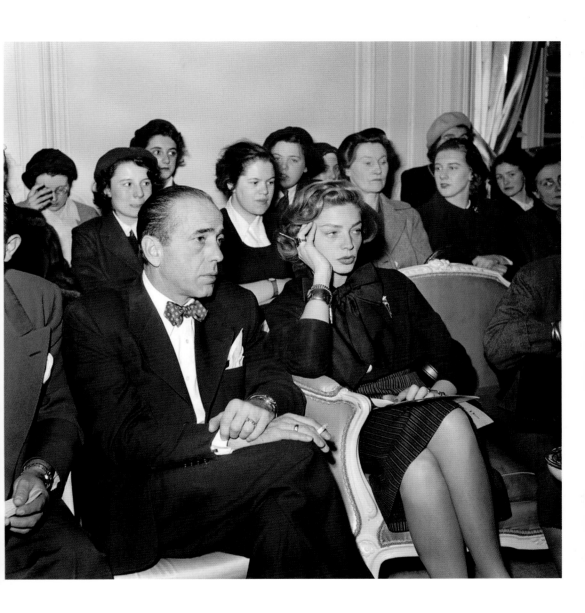

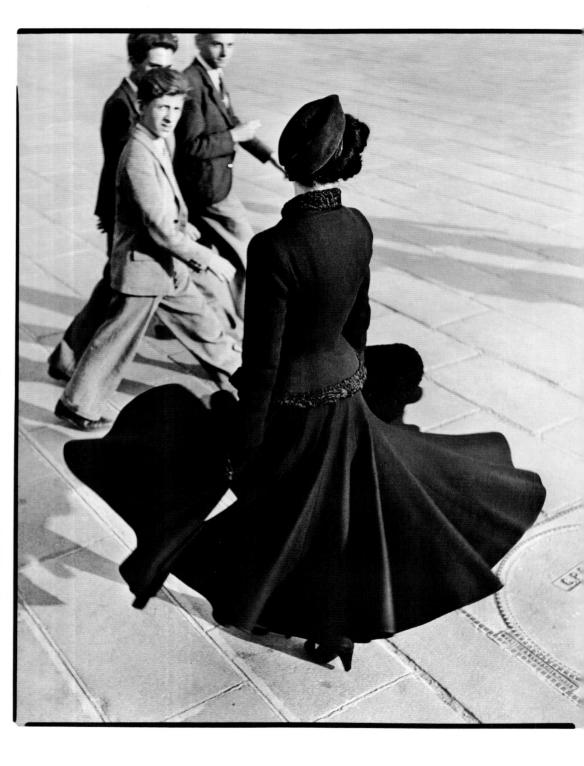

Dior would never enter the salon, nor dream of becoming entangled in the carefully calibrated psychological play between client and vendeuse. "Of course every woman is determined to squeeze into the dress of her choice," wrote Dior wryly, "regardless of the differences between her figure and that of the mannequin, and the *vendeuses* have to perform feats of diplomacy in order to dissuade them."

To Stanley Karnow he related the singular difficulties presented by his native customer: the Parisienne. "At a fitting she behaves like a contortionist. She stands up, sits down, bends and wriggles around; actually she is testing a dress because, she knows, an unhinged strap or a clasp could mean disaster at a fancy soiree. Often she brings along her husband or her lover, and they fidget as well over stitches, seams and buttonholes. They exasperate us, but we cannot afford to ignore their fussing, however petty it may seem. Unless they leave Chez Dior in complete self-confidence, we have blundered and our image will be tarnished as a consequence."

The actress Olivia de Havilland recalled a fitting at Dior as a completely integrated process. "When the second fitting was quite advanced, you begin to think about accessories. And this was what was unique about Dior. Not another dress house in Paris at that time had this kind of organisation." A saleswoman from each department would present her wares—furs, hats, bags, jewelry, gloves—to be matched with a client's outfit. By the last fitting, everything was brought together in one, unified look. In front of the mirror, surveying the final result, de Havilland recalled, "there you were, complete: completely Dior too!"

Dior's fame spread across the world, propelled by images from a new breed of reporter-photographer, such as Lee Miller, Louise Dahl-Wolfe, Robert Capa, and Richard Avedon. Here, Avedon shows the New Look in all its flaring, maximalist glory: Renée, "The New Look of Dior," Place de la Concorde, Paris, August 1947. Photograph by Richard Avedon.

Every fitting, every sale was powered by the all-pervasive, ever-persuasive image of Dior couture as the fulcrum of elegance, etiquette, and Parisian *art de vivre*. But the simple psychological fact of humankind's persistent search for novelty was a no less influential force in the fashion industry. Or, as Dior put it, "Have you ever seen a woman enter a shop and ask for 'Something just like the one I'm wearing'?"

"SURE TASTE IN ALL THAT HE
TOUCHED — UNSHAKEABLE
SIMPLICITY OF CHARACTER
— SUCH WAS CHRISTIAN DIOR."
vogue

DIOR'S LEGACY

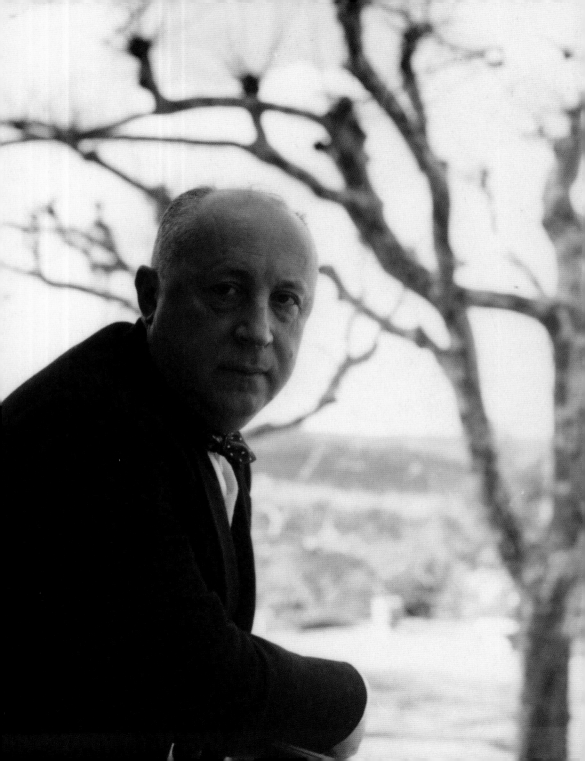

THE FIRST DECADE OF MAISON DIOR was marked in 1957 with celebration and a renewed sense of purpose. The house commanded a revenue of some $20 million a year. A *Time* magazine cover story—"Dictator by Demand"—vaulted Dior to icon status. The introduction of the waist-less chemise into Dior's design vocabulary had finally extinguished all memory of the New Look's fit and flare silhouette. Over the past decade, thousands of dresses had been produced *chez* Dior, turned out by the small, darting needles of the *petit mains* in the couturier's twenty-eight ateliers. Yet millions of women had dressed *à la Dior*, seduced by the couturier's brand of amplified femininity. It was Dior's collections that were scrutinized to confirm fashion's new direction, Dior's modes which were copied relentlessly—the name Dior *was* fashion to the world at large. True, the pejoratively dubbed "General Motors of Fashion" was no Balenciaga, presenting avant-garde lines that would influence generations of designers, nor was he Chanel, pushing her easy, sporty aesthetic, immune to the ebb and flow of trends. Yet Dior was a giant nonetheless.

Photographed for Vogue by Tony Armstrong-Jones (Lord Snowdon), Dior is pictured at his country home on the eve of the tenth anniversary of Maison Dior.

Dior was photographed by *Vogue* for the magazine's April 1957 issue. In bow tie and jacket, brown eyes staring from a pillowy white face, it's a very different Dior from that pale and pinched man of his earlier *Vogue* portrait, taken on the eve of his debut. The fashion king Dior now dominated the landscape, "the much-publicized cause of the rise and fall of bosoms, the shrink and stretch of hips, the sight and flight of knees. Often creating while floating in his green marble bathtub," wrote *Time* magazine. By 1957 Dior was at the height of his powers, as famous as the movie stars he frequently dressed. "Christian Dior, on whose creative inspiration is built a whole fashion empire (clothes, hats, furs, scent, jewellery, corsets, gloves, stockings, shoes), is a man of the most admirable simplicity, undazzled by ten years of fame," said *Vogue*. "His essential peace of mind and love of beauty are refreshed by staying at his house near Nice, where he was specially photographed for us," *Vogue* continued. "His autobiography, *Dior by Dior* has just appeared."

Unpublished photographs of Dior from Tony Armstrong-Jones' shoot for Vogue, 1957.

The book was a powerful marketing tool, another layer of burnish on the already glossy Dior image. The Dior who emerges is a mercilessly self-aware character who describes his personality in the same clear prose he uses to explain his design process and the workings of his house. An observant writer, he is witty and self-deprecating, always aware of creating an impression and the value of appearances. ("I assume that those who are not interested in haute couture and its ramifications, will not be interested in reading my book either," he writes, slyly.) Dior wrote in the knowledge that he was securing his legacy in ways that reached beyond mere fashion. It's a reflection of a career in which Dior became more than the sum of his parts, extending past couture to become a public persona, a tastemaker, a businessman, an icon. And for his designs, which, destined for a privileged few, became the mode for women everywhere.

For a couturier, an autobiography was a suit made of words, even, of armor. The urge to write his own life derived from the same instinct that prompted Dior to write his exhaustive show notes: a necessity that was nevertheless a gesture of control. Here was the truth, *his* truth, and nothing else; a view Dior confirms in his introduction, referring to himself in the third person: "I am speaking now of Christian Dior, couturier, of Maison Christian Dior, 30 avenue Montaigne, born 1947. It was in order to tell the truth about this second nine-year-old Dior that the first Christian Dior decided to write this book. He had been the subject of quite enough inaccurate discussion already, and I felt it was time to let the world know the real facts about him."

Such was the reach of Dior's fame, he found himself playfully parodied in Kay Thompson's Eloise in Paris. *In Hilary Knight's illustration, Eloise is fitted for her first couture, much to the distaste of Mitzah Bricard, sitting to Dior's right.*

The Dior of his memoirs is more good-humored than didactic. He recognized that his public perception bore little similarity to his private self. Even the title of his book is evidence of a man playing a part: published in English as *Dior by Dior*, its French title was even more revealing of his two persona—*Christian Dior et Moi*. Dior the couturier, he wrote, "is a compound of people, dresses, stockings, perfumes, publicity handouts, press photographs, and every now and then, a small bloodless (but inky!) revolution whose reverberations

M. Dior designed a dress for me
and it is absolutely chic
although I would have preferred a tassel or two
Pas de quoi

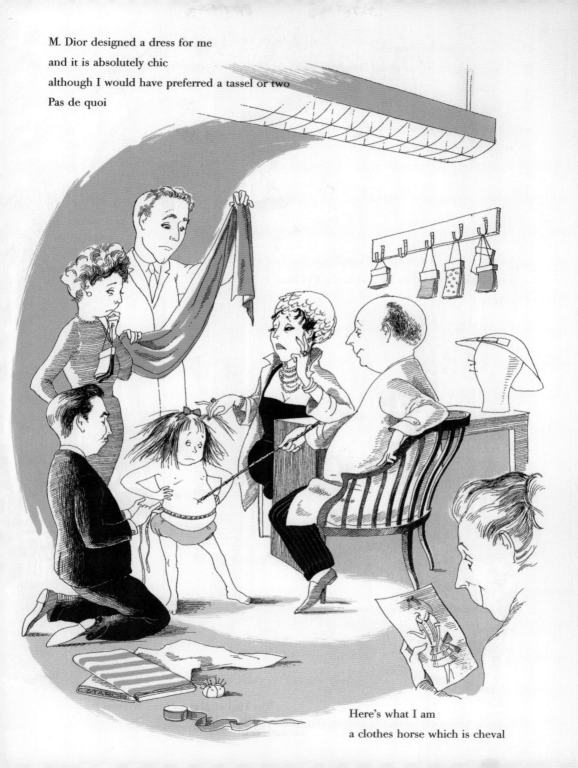

Here's what I am
a clothes horse which is cheval

are felt around the world." The other Dior, "a shrinking nonentity," detested "the noise and bustle of the world, and sudden, violent changes." (His contrasts were captured best in this description in *Time* magazine: "Christian Dior, assiduously unassuming, rarely appears at theaters, operas or balls. Mornings, he starts the day with a cup of mint tea, served in his crimson-canopied antique bed by his sinisterly handsome Spanish butler.")

The two sides of his personality served as ballast for the other. It was the Dior of ego and incision who mustered the confidence to demand his own couture house from Marcel Boussac. But it was the shy and timid Dior who ensured the couturier never became a monster of ego. As Cecil Beaton remarked, "Dior does not make the mistake of believing in his own publicity." This view was echoed in the March 1957 issue of American *Vogue*: "An established lion, he is also a generous lion, quick to praise others, warm to young newcomers in the couture, and quite blatantly adored by his couture staff, his household, and the great range of friends who come, in cheerful clutches to his salon and his house."

Whether as survival strategy, or by natural default, Dior kept his lives separate. Not least by geography, retiring between collections to his house at Moulin du Coudret, near Fontainebleau, or to the gardens of his castle, La Colle Noir, in Provence. As Dior noted of the latter: "I think of this house now as my real home, the home to which, God willing, I will one day retire, the home where perhaps I will one day forget Christian Dior, Couturier, and become the neglected private individual again." It was not to be. Dior died a year after writing these words.

"He's Atlas, holding up the entire
French fashion industry."

time magazine

His actions in the final months of his life were those of a man with an eye to the future. The designer Marc Bohan, previously at Molyneaux and Patou, had been vetted to oversee Dior's New York studio; and Dior planned to ask the twenty-one year old prodigy Yves Saint Laurent—who had worked with the couturier since 1955—to assume more responsibility for the Paris collections. Both decisions spoke of a desire to slow down.

The frenetic pace of Dior's life was a problem born of success, but also of his specific vision for fashion. "It was Virginia Woolf who exclaimed, 'How fashion revives the eye!'" *Vogue* observed in 1954. And nothing revived it more than the new. Jean Cocteau had described fashion as: "A lightning-quick epidemic which forces different and antagonistic persons all to obey the same mysterious order, to submit themselves to new habits which overturn their old ways of life, up to the moment when a new order arrives and obliges them to turn their coat once more." Dior had made his name capitalizing upon that very phenomenon. With each collection performing a schism with the last, each conveying a fresh distinction, Dior's mutating

overleaf Studies in scarlet: Christian Dior takes tea in the opulent sitting room of his Paris apartment; it was lined, draped, and upholstered in red velvet (left). A dramatic, cardinal-red look, sketched by Eric, from Dior's 1948 "Zig Zag" collection

silhouette and endless search for novelty guaranteed his legacy. But the effort involved was immense; it gave him a rod for his back, a rod that perhaps eventually broke him.

Against the advice of his psychic, Madame Delahaye, Dior traveled with Raymonde Zehnacker to the Italian spa town of Montecatini for a holiday. It was there, on October 29, 1957, after dinner and a game of cards, that Christian Dior collapsed and died of a heart attack. He was fifty-two. The news broke around the world. At 30 Avenue Montaigne the windows were draped in black velvet; bouquets of hawthorn blossoms, carnations, pinks, camellias, tuberoses, and Dior's signature flower, lily of the valley, gathered on the sidewalk in perfumed mounds, growing in such volume that the government authorized them to be placed along the route to the Arc de Triomphe. It was an unprecedented honor.

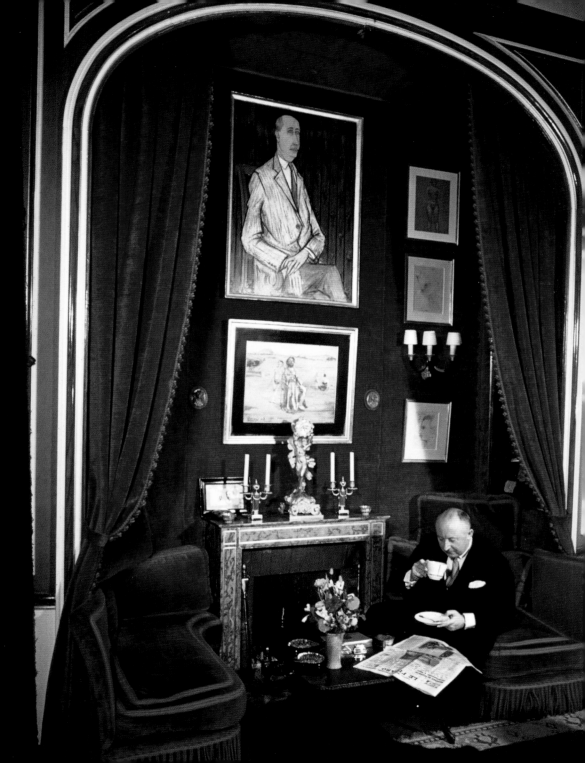

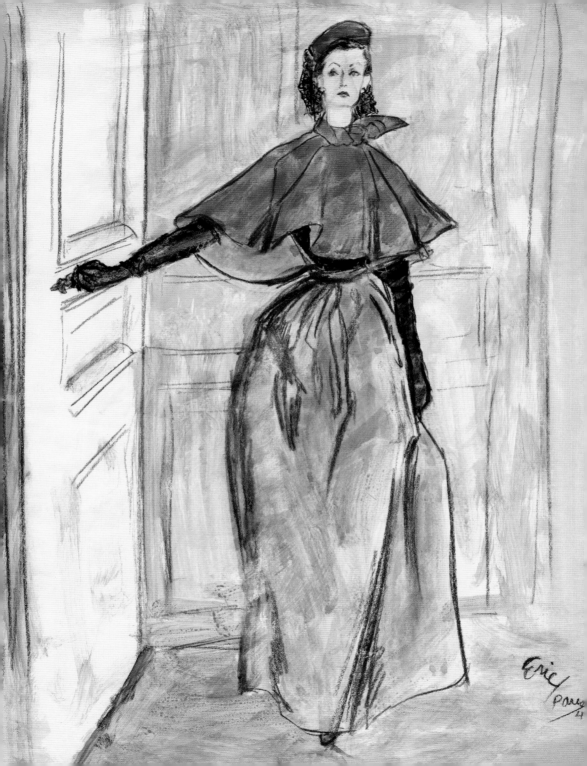

"DIOR WAS SO FAMOUS IN FRANCE AT THE TIME. IT SEEMED AS IF HE WASN'T A MAN, BUT AN INSTITUTION."

christian lacroix

P ierre Balmain, Hubert de Givenchy, Pierre Cardin, and Cristobal Balenciaga attended Dior's funeral at the Church of Saint Honoré d'Eylau. So too did Jean Cocteau and the Duchess of Windsor. Dior's most trusted colleagues and his cabine of models sat near each other in the freezing church. A question hung in the cold air: what was Dior without Dior? Marcel Boussac, Jacques Rouet, and Raymonde Zehnacker moved quickly to staunch the loss. "This fashion empire was built on his name and is to live under his name, directed by a group of his closest associates, Mlle Raymonde Zehnacker, Mme Bricard, Mme Marguerite Carré, and young M. Yves Saint Laurent upon whom his mantle has fallen," *Vogue* reported. Yves Saint Laurent was instituted at the head of Maison Dior, charged with bridging the house from past to future.

Saint Laurent pulled off his debut with aplomb, launching the "Trapeze" line in January 1958, a wedge-shaped silhouette which fell from narrow shoulders into a wide hemline. It was greeted with rapture: "In the streets the newspaper sellers shouted, 'St. Laurent [sic] has saved France,' and this indeed was the news of the Collections," *Vogue* reported in March 1958. "To the rest of the world it meant that the great Dior tradition would continue, but to the French it was a matter of national importance, and as the collections proceeded – confidently and expertly, with all Dior's famous mannequins rallied for the occasion – it was obvious that it was a great and resounding success." Such a success, in fact, that "St. Laurent had to appear on the balcony and wave to the cab drivers and passers-by, cheering and clapping in the street outside." It was the end of an era, and the beginning of the next chapter for the house of Dior.

"In the world today haute couture is one of the last repositories of the marvellous."

christian dior

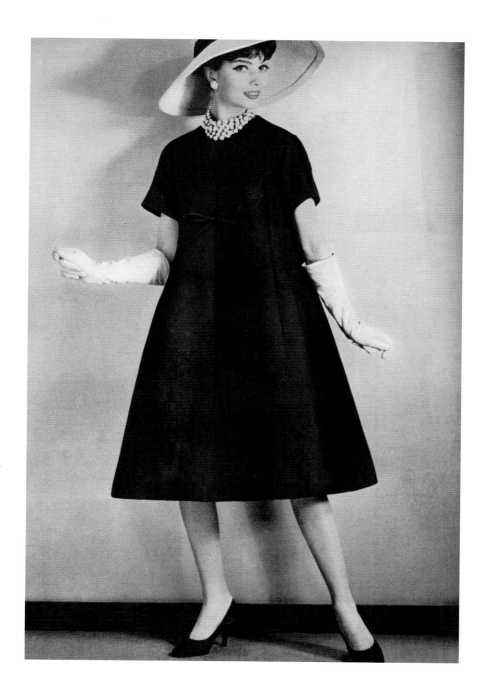

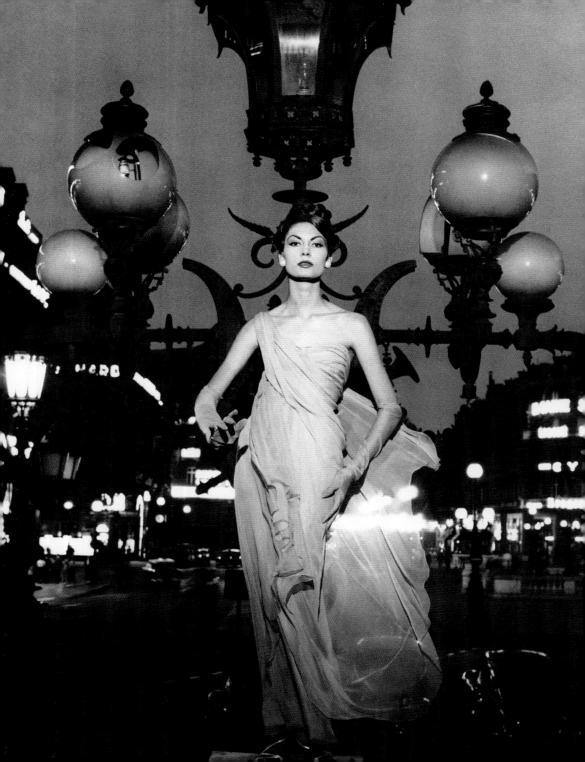

Would Christian Dior have experienced such success in any other time? Very probably. His instinct was that of all great fashion designers: to break with the contemporary fashions of the day, to uproot the dominant style. Just as Paul Poiret snipped the corset strings on Worth's Second Empire line, Chanel's tomboyish *genre pauvre* saw off Poiret's jewel-laden luxury. The postwar world, with all its bleak austerity, its half measures, and paucity, was ripe for Dior's intervention. Life in wartime was consistently sad and frequently unnerving. The New Look's maximalism, glamour, and decadent romance, gave to the world an invigorating shock. The New Look reached back into the past, connecting with Belle Epoque notions of elegance and femininity. It fed a psychological need that few knew they hungered for: the need for beauty, for extravagance, for frivolity, and exuberance after the horror of war. Thus, a collection of dresses became world news, confirming Oscar Wilde's view that "Fashion is that by which the fantastic becomes for a moment universal."

Paris by night: draped in Dior's silk chiffon, a model is photographed by William Klein for Vogue, 1957.

Success is for nothing if it is not capitalized upon. From the moment of his debut, Dior became a businessman-couturier, turning a relatively small handcraft industry into a global concern, lending his name to numerous ancillary products. He embraced his fame to become, as Bettina Ballard wrote, "one of the greatest natural publicity-inspiring characters of our time." "The audiences loved Dior because he always made it easy for them to applaud him – he never let them down," she continued. His was a world view, not just a Paris view, one that was doubtless fed by the fact that he had come to fashion design only in his thirties. His instinct for business was derived too, perhaps, from his formative experiences of poverty, his family's collapse after the Great Depression.

Dior introduced a level of introspection into his profession. He spoke at trade fairs and lecture halls in defense of couture, proving himself a fierce believer in the redeeming power of fashion. "Fashion has its own moral code," he wrote, "however frivolous." As Cecil Beaton noted, "He is something of a philosopher in his own right, and his observations about fashion and the present epoch are shrewd

and just." Many of Dior's pronouncements were framed in the breathless hyperbole native to fashion designers, but there was clear logic at work. As he wrote, "The great adventure which constitutes Parisian couture is not merely a Temple of Vanities: it is a charming outward manifestation of an ancient civilisation, which intends to survive."

Dresses that took several hundreds of hours and twice as many people to create were deemed works of art, items of unique substance and value. Yet the world of couture in 1958 was a very different place from what it had been in 1947. By the time of Dior's death, couture houses Molyneux, Lelong, Worth, and Schiaparelli had shut shop for good. All but a dozen of the biggest houses were engaged in a struggle for survival, beset by expensive labor costs, plagiarism, and the influence of a burgeoning—and young—market who favored the modish prêt-a-porter (ready-to-wear) over the services of their mother's dressmaker. Dior, however, had built his house upon solid foundations. One of the last bastions of an industry reported (with interminable frequency) to be in its death throes, Maison Dior has continued to thrive into the twenty-first century. (Even today "Dior gray"signifies a chalky hue redolent of Dior's Avenue Montaigne premises.)

Maximum elegance with minimum fuss, Irving Penn photographs Dorian Leigh in Dior's streamlined "Oblique" silhouette from 1950.

overleaf *The "Y" Line, from September 1955 (left). A model with a carpet of furs at her feet wears "a grey tweed sheath dress, a short jacket with turtleneck gilet and a grey folded stole," Vogue writes. A sketch for Vogue demonstrates Dior's "Arrow" line for Spring 1956 (right). The waistline is raised high using belt details and short swinging jackets called* caracos.

"The magic name of Dior stands for fashion to the masses. It is part of the taxi driver's vocabulary, the teenager's, and it is often the only name that rings a fashion bell in the mind of the average man."

bettina ballard

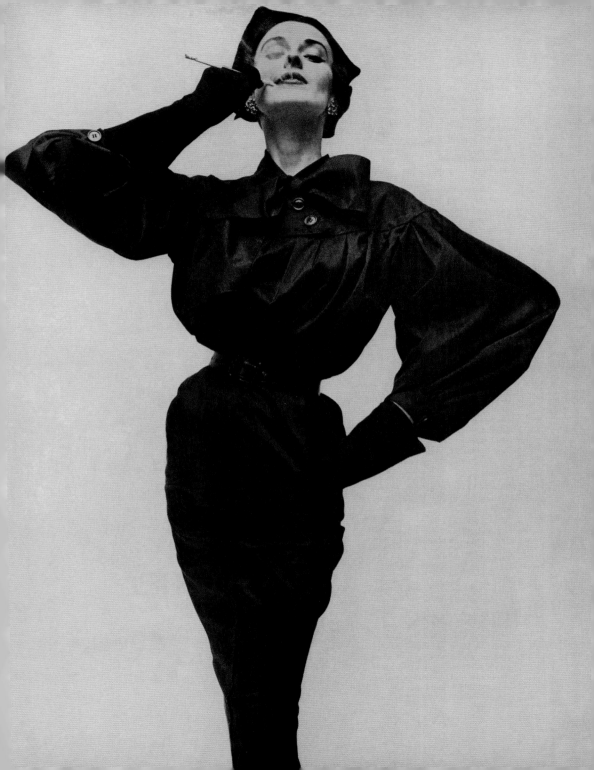

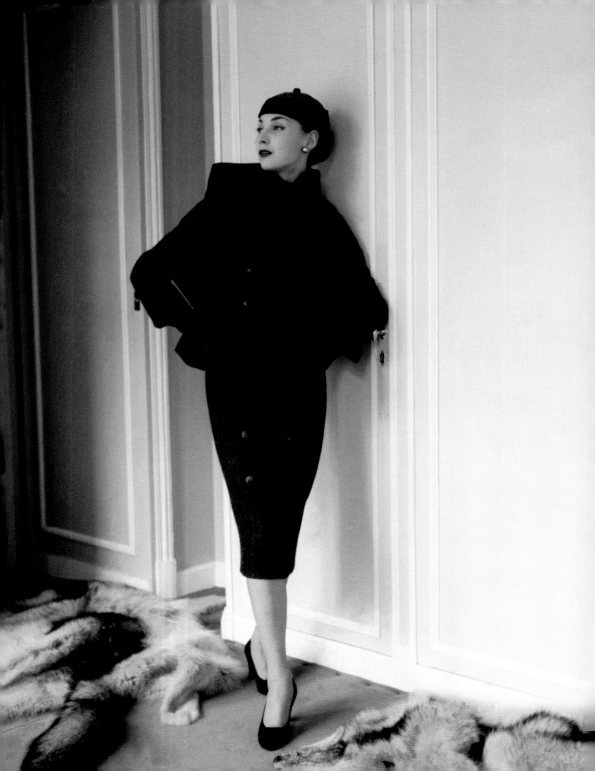

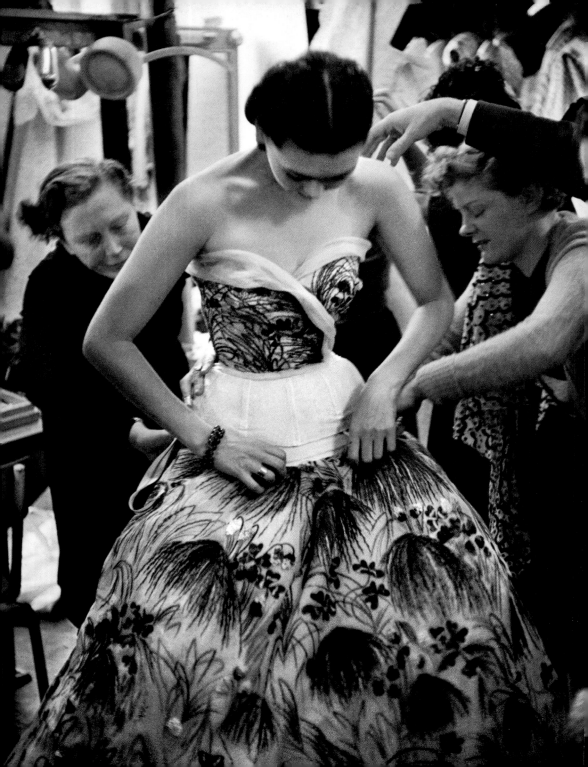

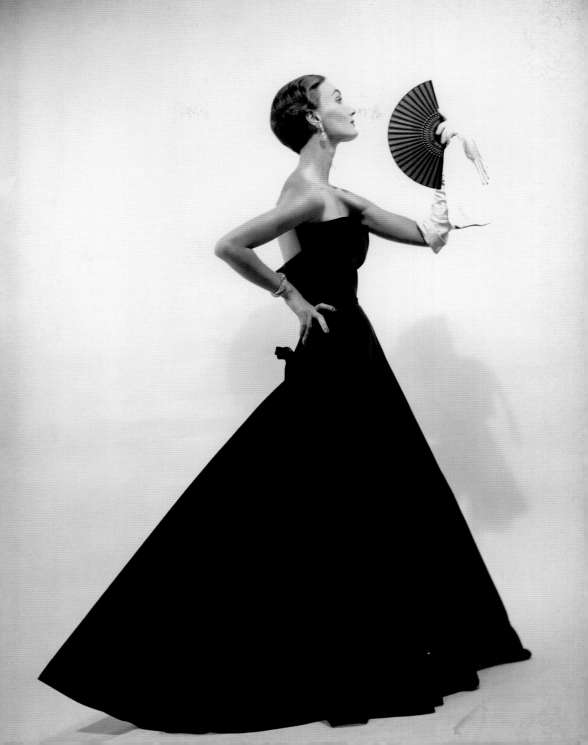

Contradiction is rife in every part of the Dior story. Soft values—his superstitions, his affectionate nature, his kindness, simplicity, and charm—contrast with hard values—his business acumen, his temper, and perfectionism. These, by turn, echo the opposites at work in his dresses, yards of tulle, silk, and satin given backbone by heavily rigged corsetry, featherlight confections constructed like architecture. The gulf between fantasy and reality can be read everywhere in Dior: in the chaos of production versus the hyper-perfection of his finished garments, in the ephemeral quality of the New Look with its air-spun glamour, set against a temporal, war-ravaged world; in the separation between the public and private Diors; in the dresses made for princesses, worn by typists. Dior did dichotomy well.

"In the world today haute couture is one of the last repositories of the marvellous," wrote Dior. But it was what Dior did with haute couture—giving a tiny, French handcraft industry a global reach and relevance—that made the marvelous truly extraordinary. "He is sure of a high place in history" *Vogue* declared. And so it was. His gift was "a brilliant, loving facility for making a woman look not only elegant but beautiful; not only fashionable, but appealing," the magazine praised. But for Dior, the couturier's art was more numinous. "The maintenance of the tradition of fashion is in the nature of an act of faith," he wrote. "In a century which attempts to tear the heart out of every mystery, fashion guards its secret well." Couture ever was, "the best possible proof that there is magic abroad."

Model Lisa Fonssagrives photographed by her husband, Irving Penn in a layered, sequinned, tulle ball gown made all the more opulent for Penn's distinct plain gray backdrop.

previous pages Photographed by Henri Cartier-Bresson (left), a mannequin is dressed backstage in "May," a ball gown embroidered with wild grasses, from Dior's spring-summer 1953 collection. A graphic sweep of black satin (right): a ball gown from 1949's "Mid-Century" collection is accessorized with a fan, white evening gloves, and a tomboy crop. Photograph by Erwin Blumenfeld.

"A person who sees only fashion
in fashion is a fool."

honoré de balzac

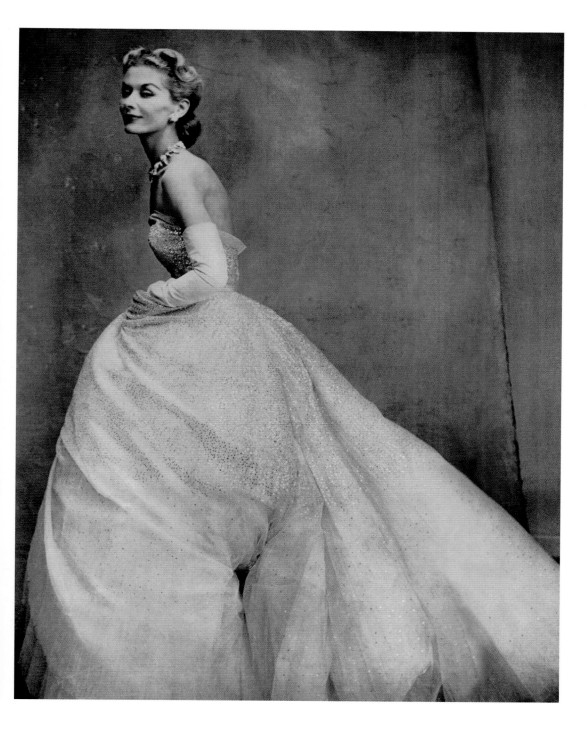

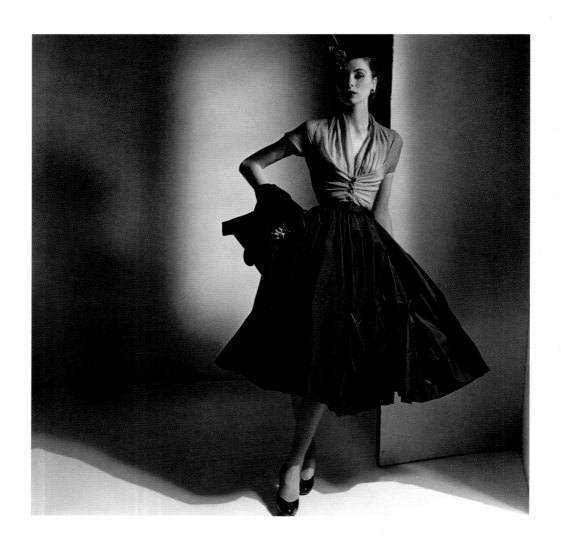

For Spring 1952, Dior's "Sinuous" line showed more
versatile, wearable styles (above). Here, a silk taffeta
skirt creeps up to just below the knee, and a shawl
collar blouse reveals a ribbon of décolletage. The Dior
waist remains handspan tiny. Photograph by Horst.
Vogue writes, in 1954, of this bright Eric illustration
(right): "A dress with the debated flattened bosom, a
coat of the newly beloved length: Dior makes them both
in the same brilliant satin, adds black fox to the coat."

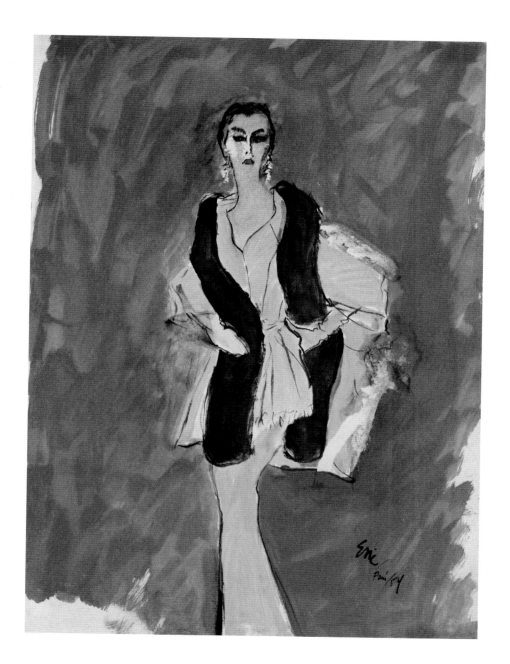

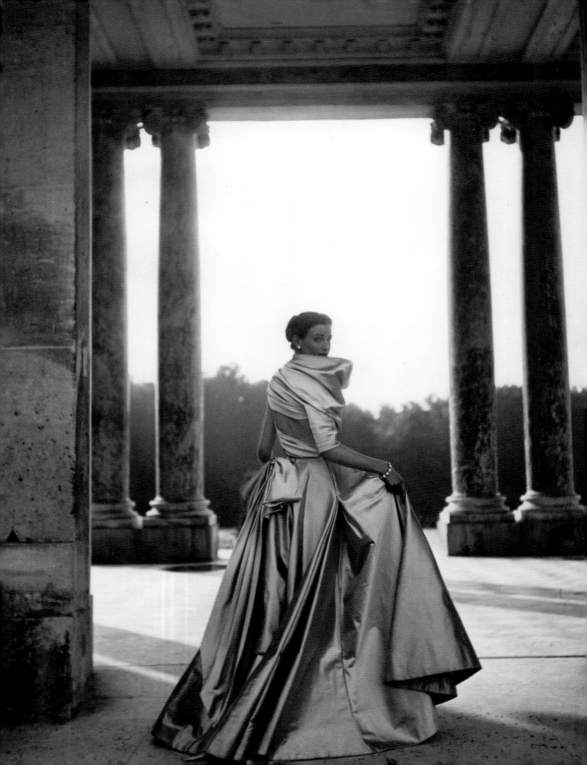

"COUTURE . . . THE BEST POSSIBLE PROOF THAT THERE IS MAGIC ABROAD."

christian dior

Silk and dusk: an asymmetric ball gown, photographed by Clifford Coffin at the Grand Trianon in 1948, embodies the romance of Dior's haute couture.

Index

Page numbers in *italic* refer to illustrations

References

Christian Dior by Diana de Marly, The Bath Press, 1990

Christian Dior by Farid Chenoune and Laziz Hamani, translated from the French by Barbara Mellor, Assouline, 2007

Christian Dior by Richard Martin and Harold Koda, Abrams, 1996

Christian Dior. The Man Who Made the World Look New by Marie-France Pochna, translated from the French by Joanna Savill, Arcade Publishing, 1996

Christian Dior: The early years 1947 – 1957 by Esmeralda de Rethy and Jean-Louis Perreau, Vendome Press, 2001

Dior by Dior: The Autobiography of Christian Dior, V&A, 2007

Dior in Vogue by Bridgid Keenan, Octopus Books, 1981

The Glass of Fashion by Cecil Beaton, Weidenfeld and Nicolson, 1954

The Golden Age of Couture, Paris and London, 1947–57 edited by Claire Wilcox, V&A Publications, 2007

Gruau by René Gruau and Joelle Chariau, Schirmer/Mosel, 1999

In My Fashion by Betina Ballard, David Mckay Co, 1960

Inspiration Dior text by Florence Muller, Abrams, 2011.

Paris in the Fifties by Stanley Karnow, Three Rivers Press, 1999

Picture credits